IMAGES
of America

STEVENS COUNTY

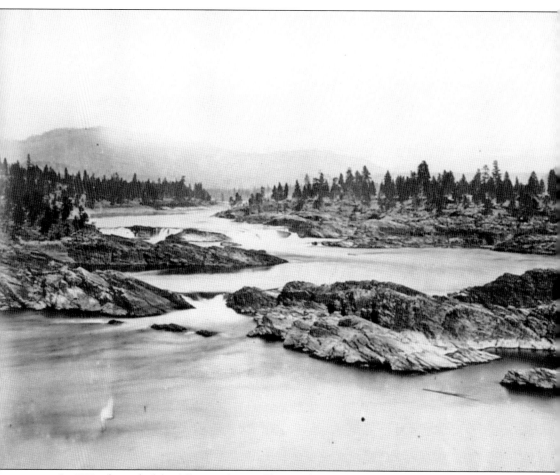

In 1811, a legend of the falls was observed by Northwest fur trader and explorer David Thompson: "a spears-men on his way to the falls to fish one day came close to the bleached skull of a dog, this contaminated his spear, so he returned to his shed to purify himself by boiling red thorn and washing his hands and spear in it." The Skoyelpis (Kettle Fall Indians) believed that keeping the beach of the river very clean would keep the fish from going away. Even fish that were caught on the river's own banks would have to be taken elsewhere for cleaning. Kettle Falls was known by many names. The indigenous people's name for it was Swaneetku, meaning "keep sounding waters" or "noisy waters." The French fur trappers called it Les Chaudieres, meaning "kettles." The indigenous people who occupied the banks of Kettle Falls were also known by many names, including Skoyelpis, Chaudieres, Ilthkoyape, Chualpays, Shwoi-el-pi, Whe-el-po, and in later years, Colville. Kettle Falls is pictured in 1860. (Courtesy of the Library of Congress.)

On the Cover: Kettle Falls was gathering place for a Paleo-Indian culture that dated back more than 9,000 years. Indigenous people used natural resources of laminated quartzite for chopping and black argillite for small tools. This picture portrays how deep some of the cauldrons or kettles were at the falls. The voyageurs called Kettle Falls "Les Chaudieres" for the numerous round holes in the hard laminated quartzite rocks. Loose boulders constantly driven around by the force of the water wore out the holes in the rock. The picture shows two men in a kettle at Kettle Falls. The man on the right is Charles Larsen, one of the owners of the Fuller-Larsen-Kelley store in Kettle Falls. (Courtesy of the libraries of Stevens County.)

IMAGES of America
STEVENS COUNTY

Kay L. Counts

Copyright © 2013 by Kay L. Counts
ISBN 978-1-4671-3043-1

Published by Arcadia Publishing
Charleston, South Carolina

Printed in the United States of America

Library of Congress Control Number: 2013933261

For all general information, please contact Arcadia Publishing:
Telephone 843-853-2070
Fax 843-853-0044
E-mail sales@arcadiapublishing.com
For customer service and orders:
Toll-Free 1-888-313-2665

Visit us on the Internet at www.arcadiapublishing.com

For my mother, Clara Counts, my son, Daniel W. Hicks, and Gene Bartlett, my cousin who has been like a father to me.

Contents

Acknowledgments		6
Introduction		7
1.	They Walked Before	9
2.	Fifty-Four Forty	19
3.	Towns along the River	49
4.	Ferries, Steamers, and Rails	97
5.	Community Life	113

ACKNOWLEDGMENTS

Writing *Stevens County* has been an enjoyable experience. Without the assistance I received in locating pictures, this project would not have been possible. On learning about the history of the area, I immediately wanted to bring some of these images to life. This book benefited from people who share my love of Stevens and its rich history. A special thanks goes out to libraries of Stevens. Also, I'd like to thank Washington State Library and Ross Fuqua for sharing his digital expertise and coming to my rescue on several occasions. Joe Barreca, from Map Metrics, made contributions that were essential to writing about the history of Stevens, and Robert E. Webb was willing to share his family photographs. In addition, I would like to thank the mayor of Marcus, Fran Bolt, for taking the time to personally call and assist me with contacts. Her kindness and knowledge of the area were very helpful. All images are from the libraries of Stevens County unless otherwise noted.

Introduction

Surrounded by rugged mountain slopes, with the rolling Selkirk Mountains running north to south, Stevens County is part of the northern Rocky Mountains. The region has two main rivers, the Columbia, running south, and the Pend Oreille, running north. Known as the Upper Highlands, this area is situated in a pristine portion of Northeastern Washington. The Columbia River was once called the "river of the west."

For these reasons, the Hudson Bay Company chose this location for its depot for the mountain trade. On April 14, 1825, Sir George Simpson, Hudson Bay Company governor in North America, met with the chief of the Kettle Falls (Skoyelpi) tribe and expressed his wish to form an establishment on his lands. With the Skoyelpi chief's approval, Simpson selected "a beautiful point on the south side about three quarters of a mile above the portage where there is abundance of fine timber and the situation eligible in every point of view. An excellent farm can be made at this place." Prior to 1846, Great Britain and the United States had joint ownership of the area.

Before Simpson's arrival at Kettle Falls, a fur trader from Montreal, David Thompson, visited the region in 1811. A large group of the Skoyelpi tribe camped in its village at Kettle Falls, as it had done for generations. The Salish Indians called the falls Shonitkwu, meaning "noisy waters," and the French voyageurs called the falls Les Chaudieres ("kettles"). This was the time of the annual salmon run, anticipated throughout the year. Nearby tribes and those from as far away as the Bitterroot Valley would gather for the festivities. The exchange of news and trade would take place and disputes would be settled, with these villagers acting as a neutral party.

For many years, the unchartered areas west of the Rocky Mountains captured the imagination of explorers, fur trappers, and artists. In 1811, little was known about the Columbia River and its tributaries, as most of its exploration was done at its mouth by early explorers such as Lewis and Clark. Navigation of the Columbia River would allow trade to be opened from coast to coast. The river needed to be explored from its source to its mouth and mapped out. In addition, the traits and customs of the peoples along its banks had to be observed. All of this information would be crucial in order to gain control of the fur trade.

By no means was this just a matter of an explorer getting in his bateau and paddling. Annoying portages had to be made several times in the course of one journey, while canoes had to be built and repaired and gummed and re-gummed. Rarely was a journey made over the Rocky Mountains without peril. Starvation was common, as were freezing conditions.

Pemmican was a staple for the fur trappers. It was simply meat, usually buffalo, reduced to a pulp by pounding it out after being dried by the sun or fire. It was then mixed with buffalo fat. The final product took about two days to prepare. Bags made from buffalo hide were filled with meat and an almost equal amount of buffalo fat, then stirred. The bags, holding 90 pounds of pemmican, occupied little space in a canoe.

Once the Hudson Bay Company bought out the interest of the Montreal-based Northwest Company, fur-trading forts expanded along the waterways of the Columbia River. After Dr.

John McLoughlin had been appointed chief factor of the Columbia Department, he wasted no time making his mark. In 1824, he assigned John Work to move the Hudson Bay Company post from Fort George to Fort Vancouver. The following year, McLoughlin assigned Work to another removal; this time Spokan House was to be removed to the newly established post at Kettle Falls, named Fort Colville in honor of the governor of the company.

John Work, in a journal entry dated April 11, 1826, had this to say about the first farming in Stevens County: "Ermatinger and Douglas brought three pigs and three young cows for Fort Colville." Joshua Pilcher, an American fur trapper and Indian agent, reported the following to the US War Department while visiting Fort Colville: "a stockade was being built, 60 to 70 acres of ground was under cultivation and crops were fine and abundant." He also stated, "wheat ground at post on hand mills, though a windmill was erecting."

The following years were a time of rapid change. The first missionaries arrived, both Catholic and Protestant, in the 1830s. Perhaps the missionaries arrived in direct response to the five Nez Perce and Flatheads who traveled over the great Rocky Mountains in 1831 to St. Louis to find the "Book of Heaven." The Jesuits and their Indian parishioners built St. Paul's Mission near Fort Colville. The Jesuits conducted vaccinations, thus keeping the willing healthy and allowing them to escape the terror of smallpox, which the Indians were all too familiar with.

In the 1840s, Canada and the United States established the international boundary in its present location. Stevens County was now officially American territory. Territorial governor Isaac Ingalls Stevens was assigned to survey the Transcontinental Railway and was placed in charge of the northern route. The British Boundary Commission showed up in the Colville area in 1859–1862 to survey along the 49th parallel, and the American Boundary Commission came down the river to conduct operations out of Harney's Depot (later the American Fort Colville).

The US Army established a military post at Pinkney City, just north of the present town of Colville. It was called Fort Colville, not to be confused with the Hudson Bay Company's Fort Colville. When the Civil War broke out, troops from the fort were sent to fight. They were replaced with two cavalries from California. The gold fever came and went, replaced with mining that turned out to be much more profitable and reliable. As the fur trade grew weak and the number of pioneer families grew, the interest of the Hudson's Bay Company shifted, and instead of furs, it dealt more in household items such as clothing, dishes, pots and pans, and building materials. With the arrival of the railroad, opportunities for growth expanded.

Beginning in 1934, Pres. Franklin Roosevelt's administration provided much-needed help to the region in the form of conservation improvements by the Civilian Conservation Corps and the Works Progress Administration. Construction of Grand Coulee Dam downriver offered jobs in 1935. Grand Coulee backed up the Columbia River to create Roosevelt Lake. In the process, some towns were flooded, and others were moved. The salmon runs that were a sacred and necessary part of life for over 9,000 years were gone. On the day that the water inundated the falls, the Colvilles (Skoyelpis) gathered once again, as they had every year, for the coming of the salmon. However, on this day, it was called the "Ceremony of Tears," to say goodbye.

One
THEY WALKED BEFORE

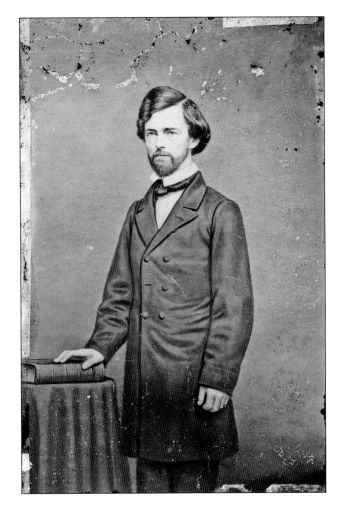

Isaac Ingalls Stevens, the first territorial governor of Washington and the superintendent of Indian affairs, was born on March 27, 1818, in Andover, Massachusetts. Following the Mexican-American War, he was given charge of the US Coast Survey in 1849. The law creating the new territory was passed by Pres. Millard Fillmore just before his term of office ended. Stevens died in the Battle of Chantilly in September 1862 at only 44 years old. (Courtesy of the Washington State Library.)

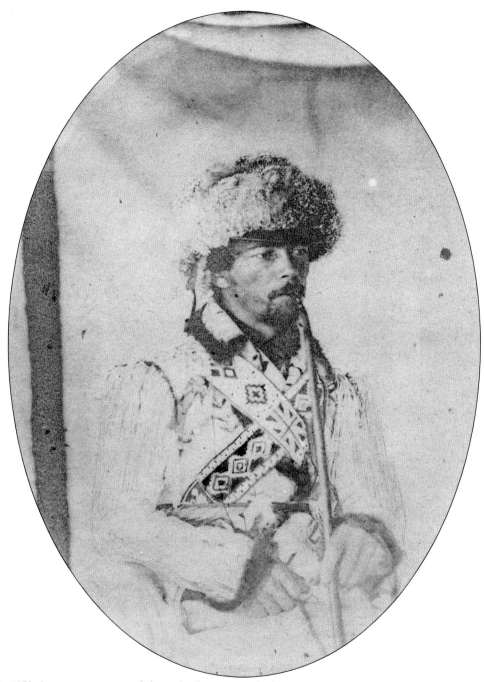

In 1853, Stevens was assigned the task of surveying the best possible route for the Transcontinental Railroad. He was responsible for the Northern Survey, covering the 47th parallel to the 49th between St. Paul on the Mississippi and Puget Sound on the Pacific Coast. His survey group consisted of natural scientists, including J.G. Cooper, surgeon and naturalist, and George Gibbs, geologist, astronomer, and ethnologist. Some of the views for his report were drawn by John Mix Stanley and Gustavus Sohon, who were a part of his expedition and treaty trail of 1855. (Courtesy of the Washington State Historical Society.)

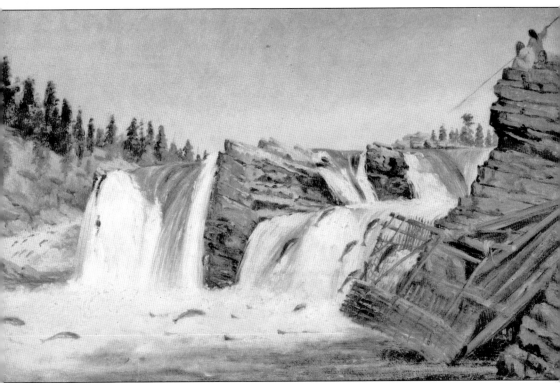

John Work, a Hudson Bay Company officer who was stationed at Fort Colville in 1826, wrote the following in his journal while visiting Kettle Falls in 1826: "Visited the falls today. They have a kind of basket about 10 ft long 3 wide and 4 deep of a square form suspended at a cascade in the fall where the water rushes over a rock. The salmon in attempting to ascend the fall leap into the basket, they appear to leap 10 or 12 feet high. When the basket is full the fish are taken out. A few are also taken with scoop net and speared." The 1847 drawing is by Paul Kane.

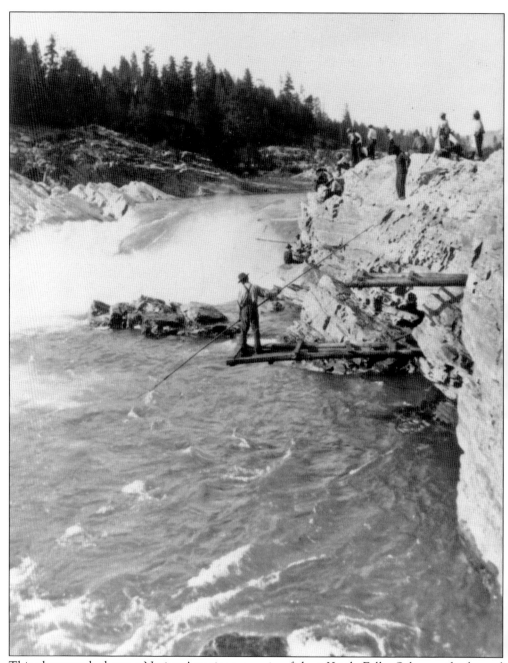

This photograph shows a Native American spearing fish at Kettle Falls. Other methods used included a J-shaped fish trap. One of the earliest recorded contacts occurred in 1811, when David Thompson, a fur trader and explorer, wrote in his diary while visiting: "The spearing of the salmon at the fall was committed for one man for the public good of course the supply was scant until the fish became sufficiently numerous to use the seine net."

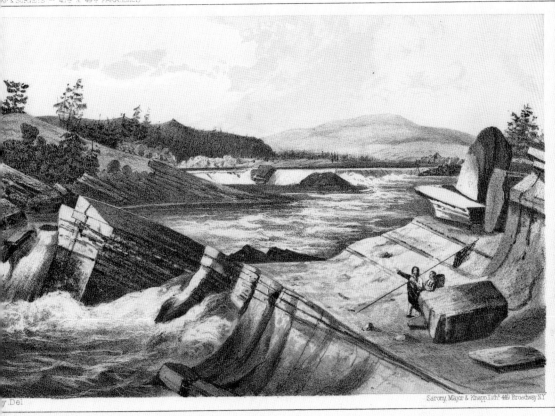

KETTLE FALLS, COLUMBIA RIVER

John Mix Stanley was one of the artists employed to assist Governor Stevens on the railroad survey in 1853, and he engraved this picture of Kettle Falls that depicts a man and a woman fishing the traditional way with a spear, net, and basket. Fish were abundant along the Columbia River. Summer was spent collecting fish for immediate use and the winter months. To supplement their diet, the natives would go inland to gather berries and roots. Close to fall, they would be off to their annual buffalo hunt. George Gibbs noted the following in 1853: "According to the information received from Father Joset, of the Jesuit mission, they number from five to six hundred. At the time of our visit, the greater part had gone to the buffalo hunt." (Courtesy of the Washington State Historical Society.)

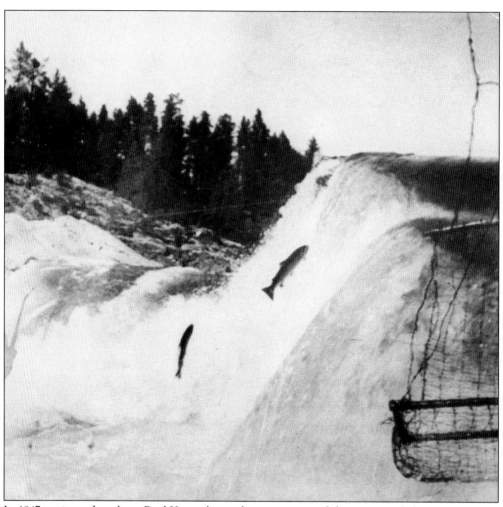

In 1847, artist and explorer Paul Kane also took an interest in fish spearing while visiting Kettle Falls. Kane observed the ancient custom with fascination: "His large fishing basket is constructed of stout willow wands woven together and supported by stout sticks of timber and is placed that the salmon in leaping up the falls strike against a stick placed at the top and are thrown back into the confined space at the bottom of the trap."

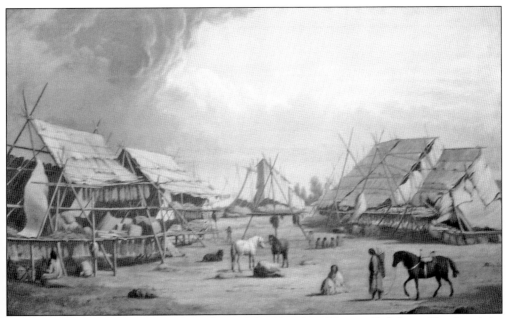

In 1847, while Paul Kane was at the village of the Skoyelpis (Kane called them Chualpays), he made this sketch with descriptions of Bush Camp/Indian Village (the fishery) at Kettle Falls; "The village has a population of about 500 souls called in their own language 'Chualpays.' The lodges are formed of mats of rushes stretched on poles. Flooring is made of sticks raised three feet from the ground."

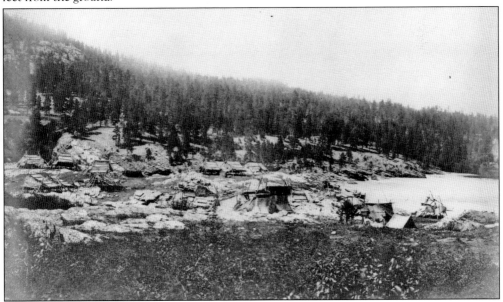

Early observer David Thompson wrote in 1811; " At this village were natives from several of the surrounding tribes as a kind of rendezvous for news, trade and settling disputes as which these villages acted as arbitrators as never join any war party." Although this 1861 photograph by the British Boundary Commission was taken 14 years after Kane's visit, the similarity between the two is evident. Archaeologists radiocarbon-date settlement in this area to the Takumakst period, 2,700 to 1,600 years ago. (Courtesy of the National Park Service.)

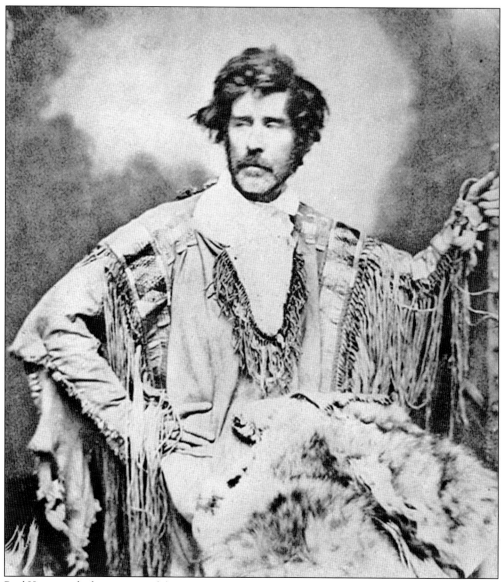

Paul Kane, with the support of the Hudson Bay Company, was able to explore the Northwest. He sketched, painted, and documented the region's culture with great detail. Upon arriving at the village of the Chualpys, he wrote the following: "The village has a population of about 55, called in their own language 'Chualpays.' The lodges are formed of mats of rushes stretched on poles. A flooring is made of sticks raised three feet from the ground." Kane also visited the Skoyelpi tribe in 1847.

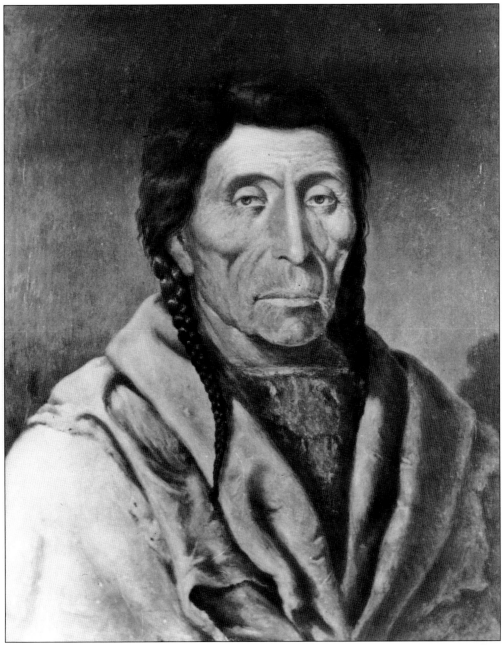

Another sketched picture by Kane in 1847 depicts See-pays (Salmon Chief) of Kettle Falls. According to Kane, the Skoyelpis had two chiefs, Allam-mak-hum Stole-luch, the "Chief of the Earth, and See-pays, the "Chief of the Waters" or the "Salmon Chief." Kane said this about See-pays; "No one is allowed to catch fish without the permission of See-Pays. The chief told me that he had taken as many as 1,700 salmon weighing on an average 30lbs. each, in the course of one day. The chief distributes the fish thus taken during the season amongst his people, everyone, even to the smallest child getting an equal share." (Courtesy of the National Park Service.)

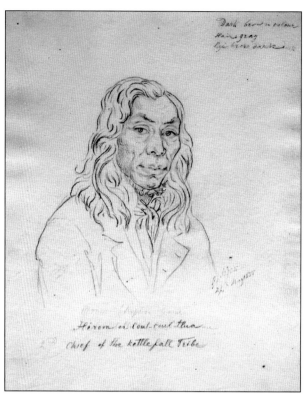

In 1853, on his railroad and treaty survey, Stevens addressed the people at Fort Colville. Some of those present were the Kettle Falls chiefs Klekahkahi, the chief at the falls; Kuiltkuiltlouis (or Hirom or Coul-coul-tlua as Gustavus Sohon called him), a sub-chief; and Elimiklka, the son of a former chief of this place. Chief Colville (Hirom or Coul-coul-tlua) was drawn by artist Gustavus Sohon during the survey of the railroad on May 27, 1855. (Courtesy of the Washington State Historical Society, Gustavus Sohon Collection.)

Chief Spokan (Spek-ha-ny), also known as Mr. Frazier, was the brother of Spokan Gary. Governor Stevens made these remarks about Spokan Gary: "I have now seen a great deal of Gary and am much pleased with him beneath a quiet exterior he shows himself to be a man of judgment, forecast, and great reliability, and I could see in my interview with his band the ascendency he possesses over them." In 1825, George Simpson picked two Indian boys to go to school in Red River (Winnipeg, Manitoba). The boys were both sons of chiefs. One was from the Spokane tribe, and the other was a Kootenai. Simpson named them Spokane Gary and Kootenai Pelly. This picture of Chief Spokan was drawn by artist Gustavus Sohon on July 3, 1855. (Courtesy of the Washington State Historical Society, Gustavus Sohon Collection.)

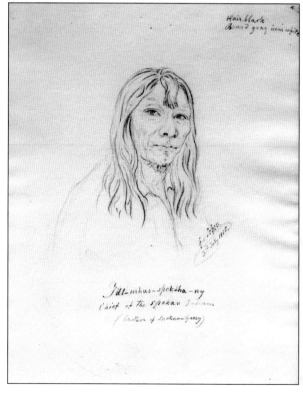

Two

Fifty-Four Forty

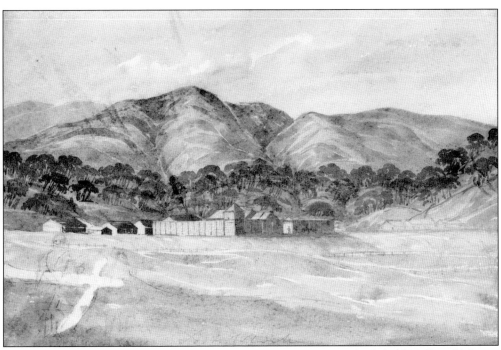

On April 8, 1825, a meeting was held between Sir George Simpson, Archibald McDonald, James McMillan, Alexander Ross, and Alexander Kennedy at Spokan House regarding dismantling the fort to a new location at Kettle Falls. In 1825, John Work, a Hudson Bay officer, made several trips between Spokan House and the new establishment, Fort Colville, to transfer merchandise. Work sent a total of 18 men to the new establishment with tools to prepare timber and if time permitted to build a store as a beginning for the new establishment. Work was disappointed on arrival to see only 24 logs had been squared. This picture of Fort La Roche (Fort Colville) was done by Henry James Warre in 1845. (Courtesy of the American Antiquarian Society.)

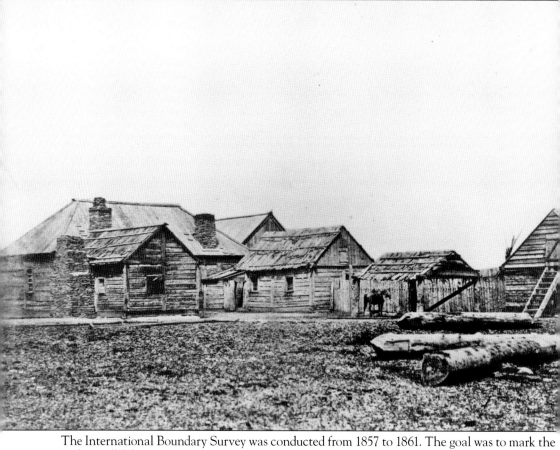

The International Boundary Survey was conducted from 1857 to 1861. The goal was to mark the 49th parallel from the west coast to the Rocky Mountains. The British survey crew constructed its own barracks at what was later known as Marcus Flats, while the US survey crew was stationed down the river at Harney's Depot (later the American Fort Colville). In 1860, the British Boundary Survey took this photograph of the Hudson Bay Company's Fort Colville that shows, from left to right, the chief trader's house, kitchen, main store (only the roof showing), family house (with a shake or bark roof), horse shed, and flour house (with stairs). (Courtesy of the Library of Congress.)

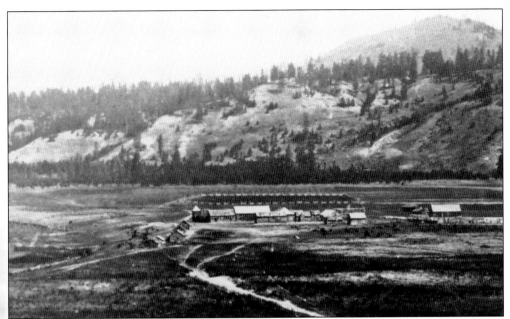

This photograph of the Hudson Bay Company's Fort Colville was taken from a bird's-eye view perspective to capture the farms and many of the buildings. Fort Colville was the principle post for the mountain trade and second only to Fort Vancouver. Its supplies were received from ships to Fort Vancouver via the Columbia River in bateaux. The photograph was taken by the British Boundary Commission in 1860. (Courtesy of the Library of Congress.)

The Hudson Bay Company's employee quarters are seen in this photograph. In September 1825, Works organized his men and was able to construct a saw pit as well as a two-wheel carriage to transport logs for the construction of the new fort. The logs were rafted down the river from the nearest source of timber to the new establishment in 1860. (Courtesy of the Library of Congress.)

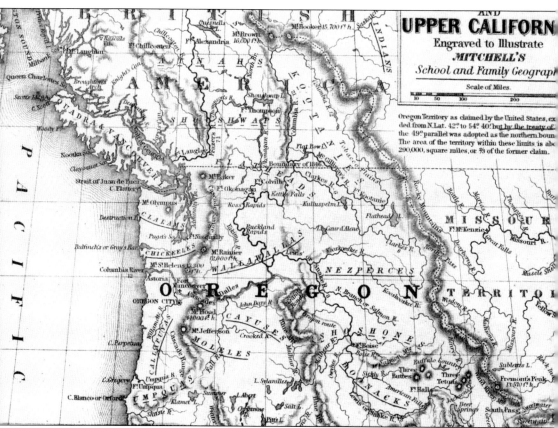

The Oregon Treaty between Britain and the United States was signed on June 15, 1846, in Washington, DC. The treaty brought an end to the Oregon boundary dispute by settling competing American and British claims to the Oregon Country, which had been jointly occupied by both Britain and the United States since the Treaty of 1818, the division being at the 49th parallel. During joint occupation, most activity in the region besides that of the indigenous people came from the fur trade, which was dominated by the British Hudson Bay Company. Shown here is a map of the area including Stevens County as it appeared shortly after the treaty of 1846. (Courtesy of the Washington State Library.)

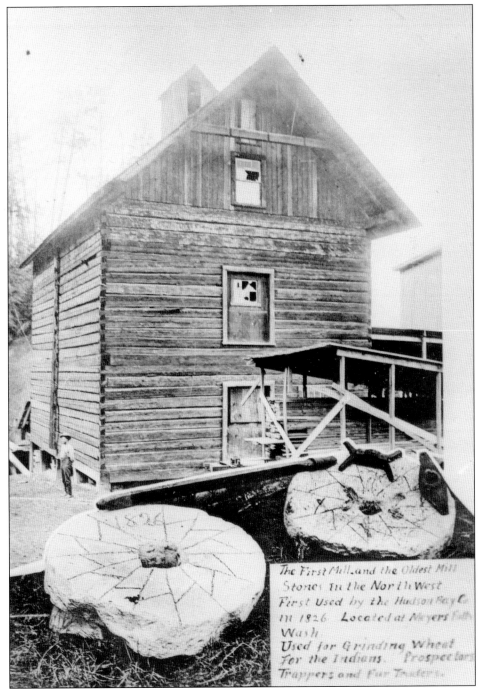

This gristmill, built by the Hudson Bay Company on the Colville River (Slawntehus), had one pair of stones. At one time, it ground the wheat that was grown on the company's farm for all of the northern posts. In 1853, during George Gibbs's visit under the command of Governor Stevens, the mill was still reportedly in decent order and provided water year-round. Gibbs also noted that a cattle post was on the same stream nine miles distant. According to Christine McDonald, the mill was rebuilt by a man named Gowdie. (Courtesy of the Washington State Library.)

George Simpson believed that the forts should be self-supporting. For example, as soon as the site for Fort Colville was chosen in April 1825, Simpson wrote James Birnie, chief trader of Spokan House, to "send a couple of men across immediately to plant 5 to 6 bushels of potatoes. In July of the same year, "six kegs of potatoes were sowed at Kettle falls and had been hoed twice." By April 1826, Fort Colville began receiving domestic animals, pigs, cows, and horses, along with seed potatoes and tools for farming. With this, the farming of Stevens County began. This photograph, taken in front of the Hudson Bay post quarters, includes a buggy and horses. (Courtesy of the Washington State Library.)

The Fort Colville officer's post was once located in this white house. Since Fort Colville was once the post of the chief factor, the highest officer in charge of a station, the annual accounts of the whole country were consolidated here. The chief factor's post had been transferred across the mountains. When Gibbs arrived in 1853, the fort consisted of "Mr. [Angus] McDonald, Chief Clerk, a trader, and about twenty Canadians and Iroquois Indians."

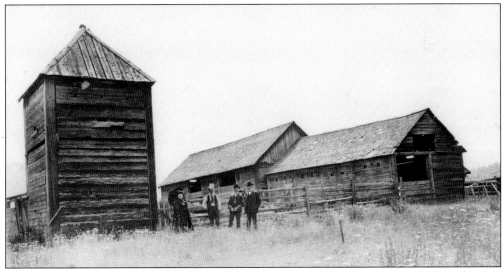

A woman with an umbrella and three men are pictured at Hudson Bay's Fort Colville. The man with the beard might be Angus McDonald or his son, Donald McDonald. In September 1829, Fort Colville had 25 men stationed in log houses, which also held merchandise and furs. A stockade was being built, as was a windmill, as wheat was being ground at the post by hand mills. Some swivels and common firearms were present. From 60 to 70 acres were under cultivation. Abundant crops included wheat, barley, oats, Indian corn, Irish potatoes, peas, and garden vegetables. Domestic animals, such as cattle, hogs, and horses, supplied the post with its own food, including butter and milk. (Courtesy of the Washington State Library.)

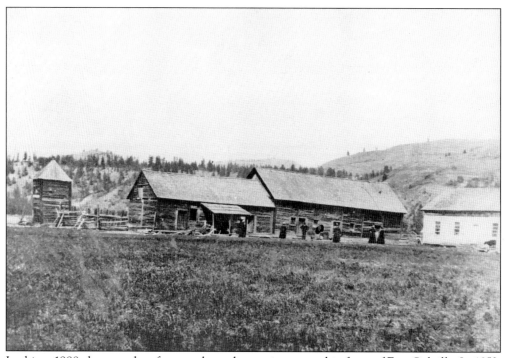

In this c. 1888 photograph, a few people, perhaps priests, stand in front of Fort Colville. In 1853, "about 30 yards to the rear of this square was a cattle yard and hay sheds enclosing a space of 40 by 60 yards, roughly fenced in. Among the structures were sheds covered with bark. On the left of the square, there were seven huts occupied by employees of the company. On the right of the square, in the rear at a distance of a few hundred yards, were three more buildings used for storing produce. One bastion remained," according to George Gibbs. The blockhouse shown here was built of 10-inch tamarack. (Courtesy of the Stevens County Historical Society.)

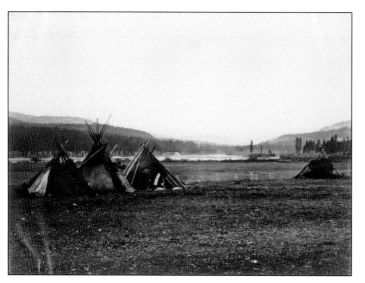

Some Salish people spent winters in teepees, like those pictured here at the Fort Colville Indian encampment. These dwellings were built around holes that had been dug in the ground to hold fires. The holes were lined with green bark peeled from cedar trees. Mat-covered floors and blankets made of animal skins were also used to keep warm. This picture was taken by the British Boundary Commission in 1860.

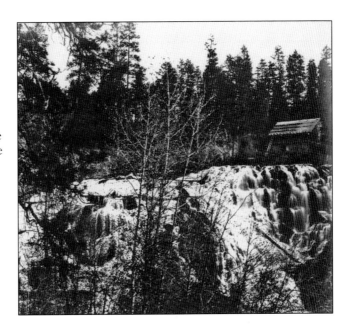

Christine McDonald (daughter of Angus McDonald) wrote in her memoirs: "Once an old Gentleman came up with father there [Victoria, Canada] a-little-old man-and brought me a beautiful bouquet. He brought them to me several mornings. He was Gowdie, the old Fort Colville Blacksmith and millwright. He told me how he took a granite rock at Kettle Falls and dressed it down for the Hudson Bay Company mill at Colville [Meyers Falls] when it was built under my uncle's administration [Archibald] in the early forty's." The picture shows the Hudson Bay gristmill in 1860. (Courtesy of the Library of Congress.)

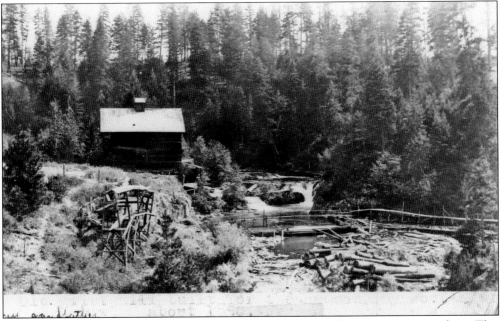

The flour for the mountain posts was ground from wheat raised on the company's farm. This farm was once pretty extensive. A later picture captures the Hudson Bay gristmill on the Colville River (Slawtehus) in 1914. The Indians' lives changed and they grew accustomed to the new tools, clothing, and food that were available at the forts. The tribes were no longer meeting all their needs from the resources around them. The caption reads: "Old Grist Mill built for the Hudson Bay Co. by my father in 1850." (Courtesy of the National Park Service.)

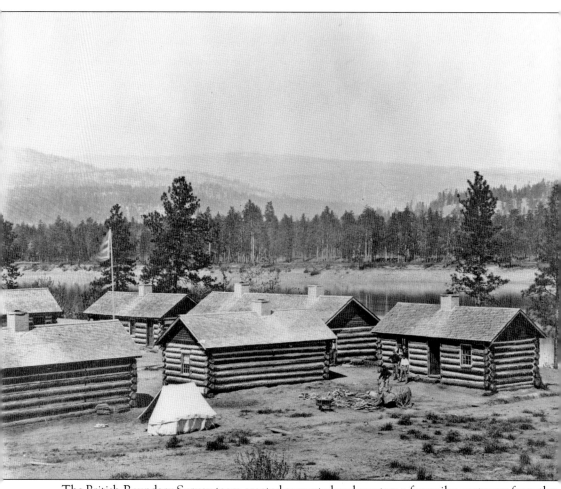

The British Boundary Survey team erected separate headquarters a few miles upstream from the trading post on land that would later be occupied by the town of Marcus. Lt. Samuel Anderson wrote several letters to his sister Janet back home. In one letter, he refers to the culture around Kettle Falls: "The Indian trappers were bringing in mostly bear and marten to Hudson Bay Company traders" and described a Lakes (Sinixt) winter village across the river from his village. This picture of the British Boundary Commission at Colville was taken in 1860–1861. (Courtesy of the Library of Congress.)

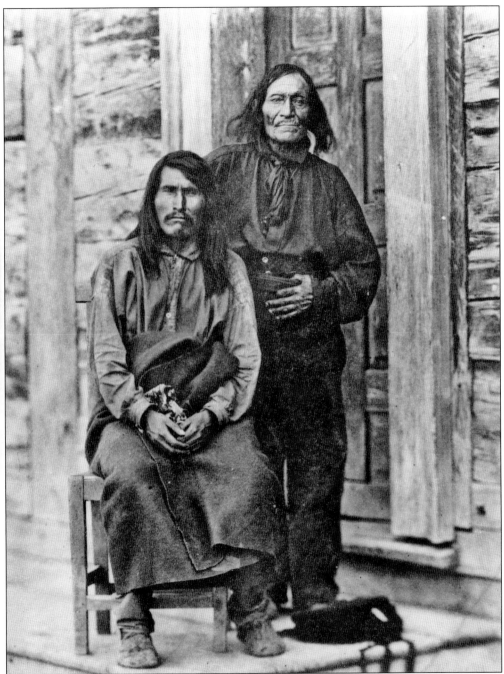

As early as 1853, Chief Kinkinahwa was salmon chief at Kettle Falls. The five-day first salmon ritual, held under the direction of the salmon chief, was the most important ceremony. Other important ceremonies included the midwinter spirit dances and the first fruits rite. The midwinter dances served the additional purposes of bringing people together and releasing winter tensions. Chief Kinkinahwa, seated on the left, was the last known salmon chief. The other man shown in this picture is Baptiste. They are pictured in 1860-1861 at the British Boundary Commission at Hudson Bay's Fort Colville. (Courtesy of the National Park Service.)

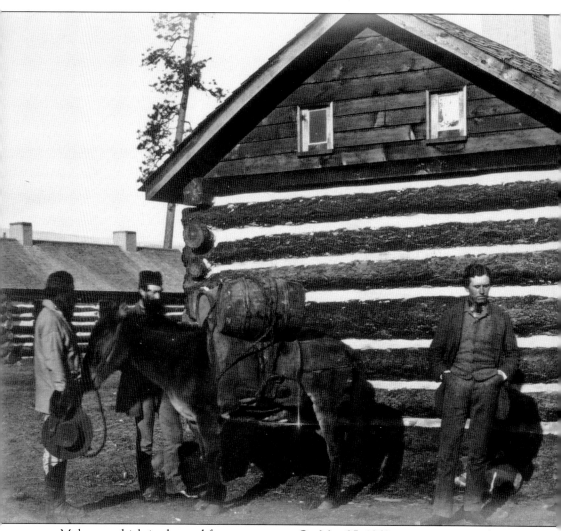

Mules were high in demand for survey crews. On May 25, 1860, seventy-seven mules were sent over by steamer up the Dalles and then brought to Fort Colville. An average pack train into the larger mining camps would average about 25 mules. Muleteers required skill and strength. Loading and unloading required pairs, one on each side of the animal. Each man had to swing his half of the heavy pack up from the ground onto the animal's back. To round up, load, and unload 25 packs in one day was a real job. The men standing in this 1860–1861 photograph are, from left to right, John Keast Lord (with hat), a muleteer, and Hillary Meinhardt Bauerman. (Courtesy of the Library of Congress.)

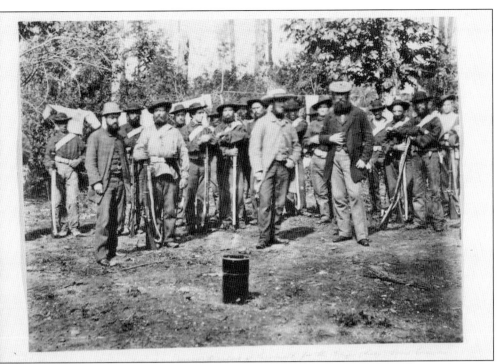

The first party of the International Boundary Survey prepared to embark at Esquimalt for the Frazier River. The commission contained both US and British surveying teams working separately toward a shared goal. These teams consisted not only of officers, naturalists, artists, and professional surveyors but also large numbers of laborers who cleared trees and set markers. On November 6–8, 1860, a meeting was held between the British and American surveyors at Harney's Depot. (Courtesy of the Library of Congress.)

While stationed at the British Boundary Commission barracks, Lt. Charles Wilson wrote the following: "We had a rather amusing scene here the other day; the departure of Macdonald, the Hudson's Bay officer here and his family on a hunting expedition. They went off mounted by twos and threes; Mrs. Macdonald, a French half-breed, leading, perched high up on a curious saddle used by women here, one of her younger daughters behind her and the baby swinging in its Indian cradle from the pommel." A similar cradle from 1860–1861 is pictured here. (Courtesy of the Library of Congress.)

Wilson continued, "next came Miss Christine who is about 17, with her gailey beaded leggings and moccasins and gaudy shawl flying in the wind, she had a younger sister behind her and in front a small brother perched like a young monkey on the high pommel; next came the boys two and two on horseback and last Macdonald himself on his buffalo runner, surrounded by a crowd of Indians and half-breeds, to which add some 40 or 50 pack horses and spare animals." (Courtesy of the National Park Service.)

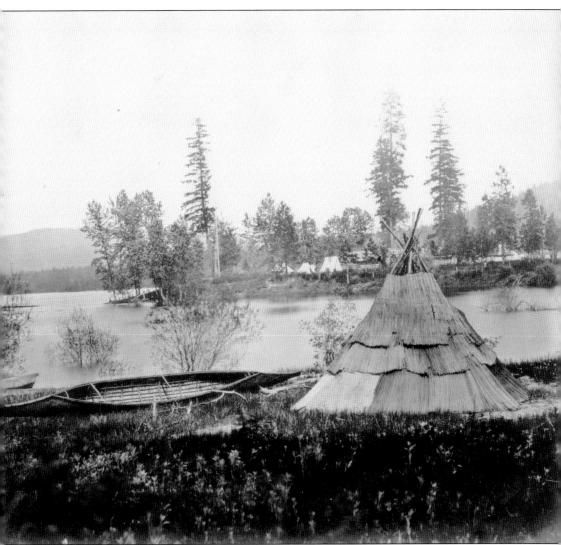

Mary Marchand said that holes for underground housing were very much in evidence around Nancy Creek in 1910. The holes were six feet and covered teepee-style with green peeled bark of cedar and were entered by ladder. James A. Teit, in the 45th annual report to the US Bureau of Ethnology in 1928, stated that "lake Indians used bark lodge instead of the lodge woven from tules which the Colville used." This 1861 photograph shows a teepee and a canoe across the Pend Oreille River from the British North American Boundary Commission depot at Siniakwateen. (Courtesy of the Library of Congress.)

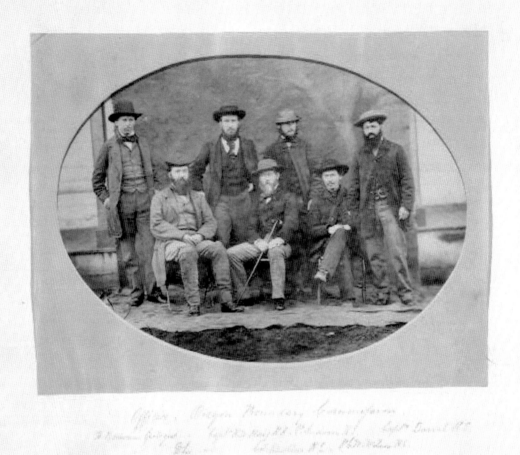

Officers of the Oregon Boundary Commission Survey in 1860 are, from left to right, Dr. Hilary Bauerman, geologist; Capt. Robert Wolseley Haig, R.A. (Royal Artillery); Lt. Samuel Anderson, R.E. (Royal Engineers); Capt. Charles John Darrah, R.E.; Dr. David Lyall; Col. John Summerfield Hawkins, R.E.; and Lt. Charles William Wilson, R.E. Some of the US Boundary Commission who were stationed at Harney's Depot were Archibald Campbell, Esq.; Lt. John G. Park, US topographical engineer; William Warren, secretary to the US commission; Joseph S. Harris; George Gibbs; and Charles Gardner. (Courtesy of the Library of Congress.)

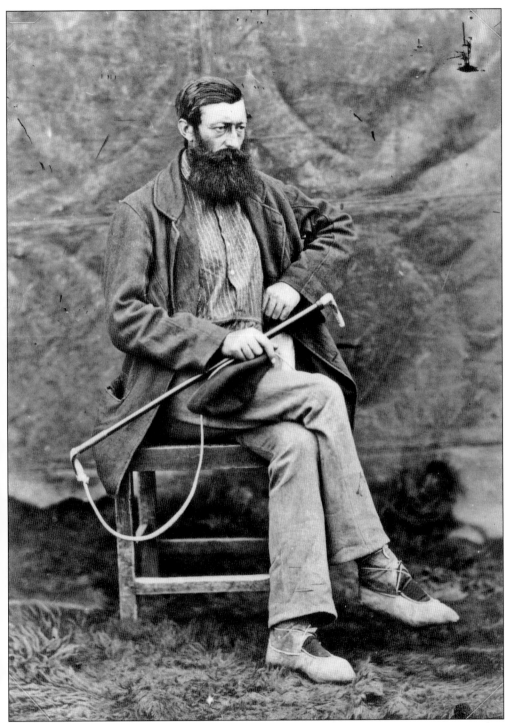

John Keast Lord, posing here in 1860 or 1861 with his dog whip, was a veterinarian, naturalist, and author. Lord was stationed in Fort Colville in 1860. He had served as a veterinary surgeon in the Crimea. While in Okanogan Valley in 1860, Lord wrote, "If there is an Eden for water-birds, the Osoyoos Lakes must be that favored spot." (Courtesy of the Library of Congress.)

Sir Charles Wilson wrote in his diary while stationed at the boundary commission headquarters in Fort Colville: "January 26, 1861: We were quite swamped with 10 visitors and in this country where people dine they sleep. Col. Hawkins gave up his house to two ladies and their husbands. We got a very decant dinner and had a jolly evening, singing dancing." He continued, "What would English people think of driving 15 miles with the thermometer at zero and 18 inches of snow on the ground? But here distance is never thought of for a moment when any excitement is going on." He is pictured in 1860 or 1861. (Courtesy of the Library of Congress.)

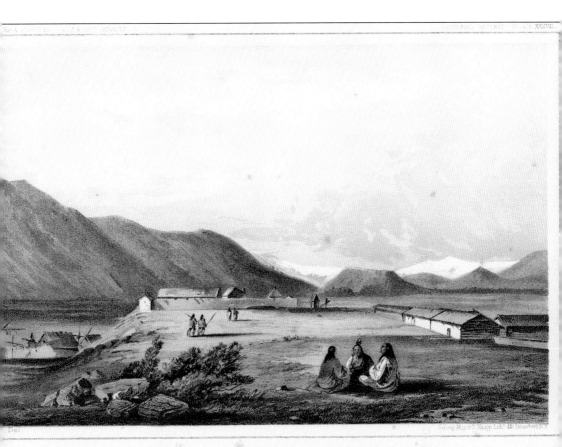
FORT OKINAKANE

In 1853, George Gibbs and Capt. George B. McClellan visited Fort Okanogan. Joaquin Lafleur was a Hudson Bay chief trader stationed at Fort Okanogan. Lafleur advised them of a foot trail leading from the headwaters of the Meathow River to Puget Sound. In 1853, George Gibbs described Fort Okanogan: "Situated on a level plain on the right bank of the Columbia, a little above the mouth of the Okanogan River [Mil-a-kite-kwa], and not far from the site of one of Mr. Astor's posts. The fort consists of three small houses, enclosed with a stockade. There were formally some outbuildings, but they have been suffered to decay." Joaquin married Margaret La Petit, an Okanogan. Lapechion, chief of the Okanogans, was her brother and is buried at the old fort. Her father was Siahooken. Joaquin had three children: Joseph Lafleur, Michel Lafleur, and Julie Lafleur de Gasper Desautel. The picture was drawn by John Mix Stanley. (Courtesy of the Washington State Historical Society, Stevens Lithographs.)

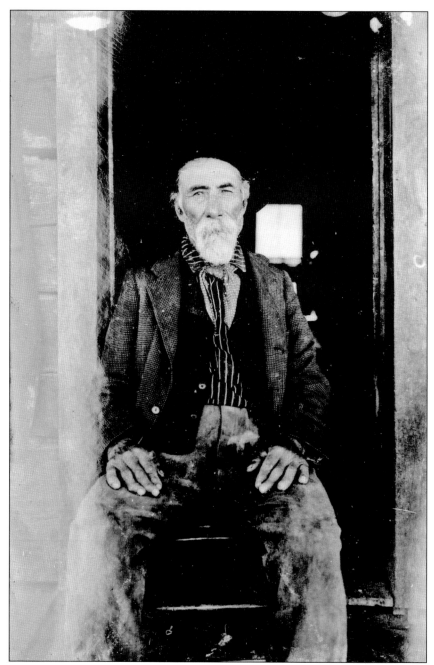

Joseph Lafleur is seen here on May 28, 1912. The Washington State Historical Society and the Indian Department interviewed Lafleur to gather information regarding Fort Okanogan and to point out the exact location of the old Astor Fort (American Fort). Lafleur was born at Fort Okanogan and lived there until he was around 18 years old. His family made several pack-train trips between Okanogan and Fort Kamloops (Thompson's River). The majority of the time, Joaquin took all the family when he went to Fort Kamloops, sometimes staying several years at a time. (Courtesy of Washington State University, Manuscripts, Archives, and Special Collections, Avery Collection.)

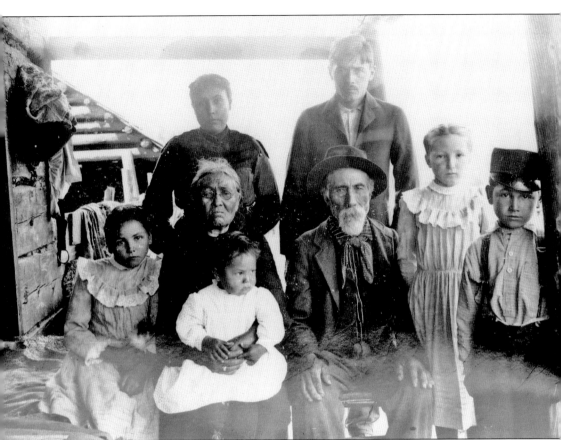

Joseph Lafleur (right) is pictured with Josette Lafleur (left), Michel Lafleur's wife, and unidentified children. Joseph was baptized at the mission at Fort Colville by Modeste Demers at two years of age on August 30, 1839. His sister Julie, three years old, was baptized the next day. Joseph's father Joaquin died in August 1859. The mortality schedule states that he was drowned, but according to Joseph, he was shot and robbed and was found in the water. (Courtesy of Washington State University, Manuscripts, Archives, and Special Collections, Avery Collection.)

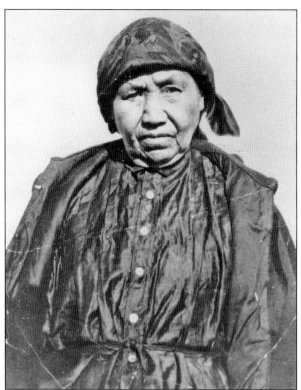

Sophia Provost Toulou (pictured) had two sisters, Victoria Provost Marchand and Josette Provost Lafleur. Sophia married Emil Toulou in 1858. (Author's collection.)

Victoria married Joachim Marchand in 1855. Victoria was baptized at the mission in Colville in 1840. Traditional clothes that were worn by women of the plains were a bark breech-lout or apron, a bark poncho, winter leggings (hemp for women and fur for men), deer and elk moccasins fashioned with beads, and a long dress made of buckskin. Everyone would have robes of deer and rabbit skins. Snow shoes were made for walking over deep snow. Women were modest all year around. Below is a picture of Victoria Provost Marchand. (Courtesy of Lou Stone.)

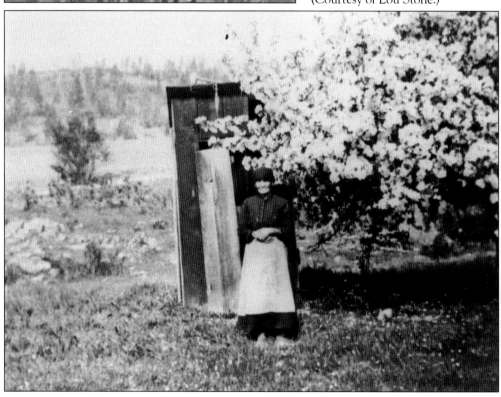

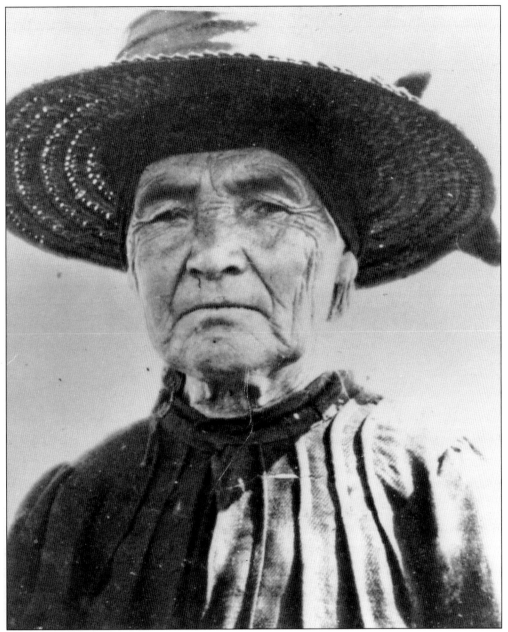

Josette Provost Lafleur was the daughter of Ludivcus (Louis) Provost, a Hudson Bay employee, and Julie Ilthlake ("women of the lakes"). After Louis died in 1846, Julie married a man named George Hak, or "Hawk," an Okanogan Indian. Josette married Michel Lafleur, son of Joachin Lafleur, on May 29, 1860. Julie was from the Lakes tribe, what is called Sinixt around the Arrow Lakes area. (Author's collection.)

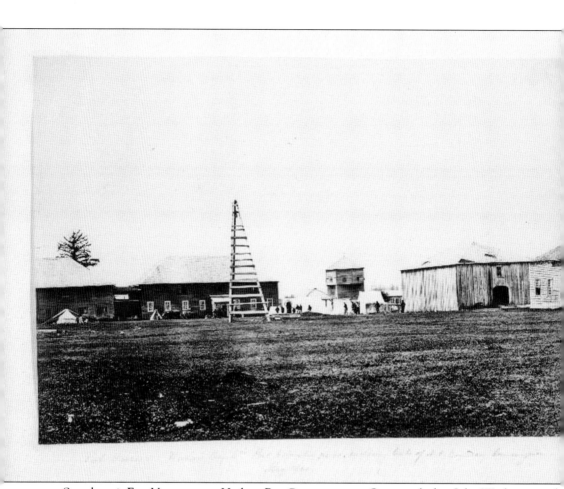

Seen here is Fort Vancouver, a Hudson Bay Company post. One year before John Work removed Spokan House to Fort Colville, he did the same at Fort Vancouver. The company decided to close Fort George and transfer the merchandise to the new establishment at Fort Vancouver. The photograph was taken in 1860 by the British Boundary Commission. (Courtesy of the Library of Congress.)

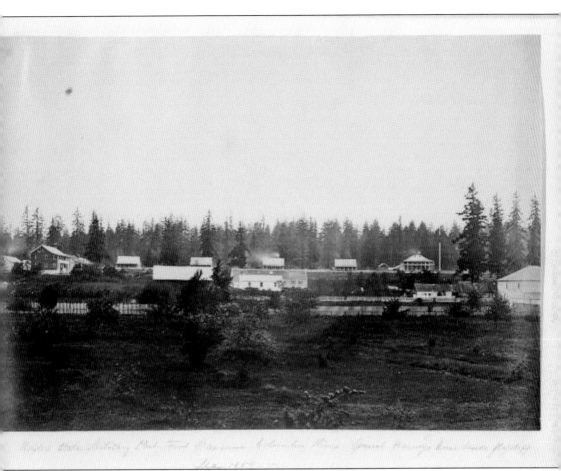

This photograph of Fort Vancouver was taken in 1860. John Work logged the following about Fort Vancouver: "April 2–3, 1824. The men employed packing the furs; Some things in the other stores were also examined and prepared for packing. The freemen were off to the new fort [Fort Vancouver]. This being Easter Sunday and it not being customary for the Canadians to work they were not employed. But Mr. McKenzie and I were busy packing all day." (Courtesy of the Library of Congress.)

St. Paul's Mission was one of the first missions in Stevens County. While Fr. Pierre-Jean de Smet was at Fort Colville in 1845, he wrote this in his journal: "Eight to nine hundred Indians, Chaudieres, Okanogans, and Sinpoils, gathered for the salmon fishing. Upon a rock overlooking the river I erected my little bark chapel, around which were grouped with the Indians' huts." He noted that more than 100 children and 11 old people were baptized. Many of the latter were carried on buffalo hides. He also noted that he closed the religious exercises with the feast of St. Ignatius. This picture is from 1860 or 1861. (Courtesy of the Library of Congress.)

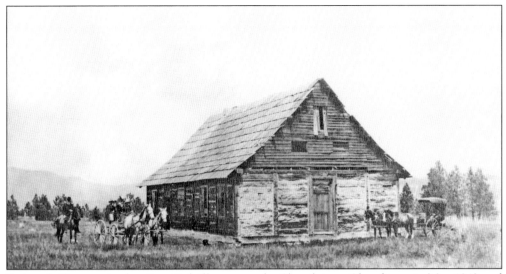

Father de Smet arrived at Fort Colville among the Skoyelpis or Chaudieres in May 1842 and translated prayers into their language. He baptized all the younger children who had not received the sacrament before, as Modeste Demers had already made two excursions among them. The great chief and his wife had longed sighed for baptism, which he administered, naming them Martin and Mary. De Smet states: "The chief is one of the most intelligent and pious I have become acquainted with." St. Paul's Mission is pictured in 1887. (Courtesy of Jesuit Oregon Province Archives, Image identification 156.09.)

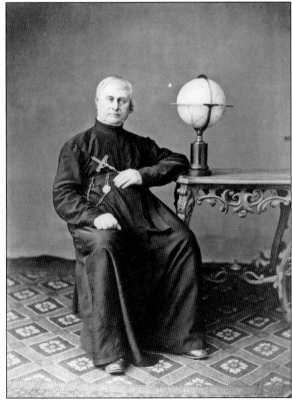

Pierre-Jean de Smet was a missionary among the North American Indians. He was born at Termonde (Dendermonde), Belgium, on January 30, 1801, and died at St. Louis, Missouri, on May 23, 1873. De Smet's missionary journeys were partly due to the work of Jesuit missionaries two centuries before. A Native American tribe in Montana, the Salish (Flatheads), heard of the "black robes" from a group of Iroquois trappers. In 1831, the Salish and Nez Perce tribes sent delegations to St. Louis to find the "Book of Heaven" so they could learn about Christianity. This began the journeys of Father de Smet, who over the years would cover more than 180,000 miles throughout the Rocky Mountains and parts of the Pacific Northwest. Father de Smet, SJ, is pictured around 1865. (Courtesy of Jesuit Oregon Province Archives, Image identification 802.01.)

In 1862, the first St. Francis Regis Mission was built under the name of Immaculate Conception, also known as Wards Mission. It was located near St. Paul's Mission. The Catholic soldiers who were stationed at Fort Colville helped build it. Since the two churches were too close together, another church named St. Francis Regis Mission was erected in 1869–1870. (Courtesy of the Washington State Library.)

When the original Colville Reservation was established on April 9, 1872, it included Colville Valley and therefore St. Francis Regis Mission. Three months later, on July 2, 1872, the reservation's boundary was moved to the north side of the Columbia River by President Grant. This action excluded the mission from the land of the Indians. In spite of the proximity, in 1873, the Jesuit fathers decided to move the mission about three quarters of a mile nearer to St. Paul's. This became the third St. Francis Regis Mission. The mission's fathers house and school are pictured around 1905. (Courtesy of Jesuit Oregon Province Archives, Image identification 158.2.01.)

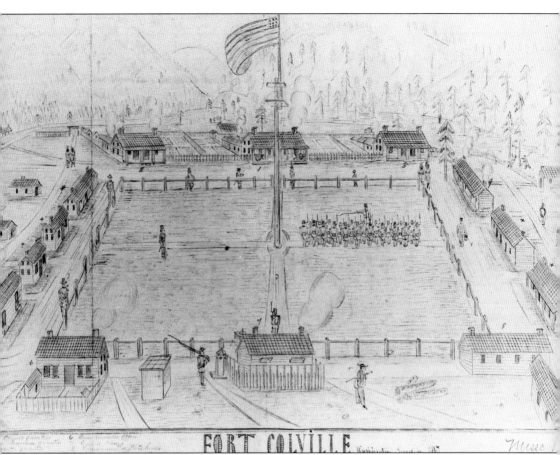

The site for the American post was chosen by Capt. Pinkney Lugenbeel near the present site of Colville, and by June 24, 1859, men were cutting timber and making shingles for the roof of the quarters. There was a sawmill three miles away and a gristmill 10 to 12 miles away. Initially it was called Harney's Depot, named for Brig. Gen. William S. Harney, who authorized a fort as a means for defending miners and settlers encroaching into Indian tribal land. It later was named Fort Colville. Naming the American post Fort Colville caused much confusion at the time and still confuses historians today. This fort also served as headquarters to the US Boundary Commission. Four companies of the US Infantry were stationed there. (Courtesy of the Washington State Library.)

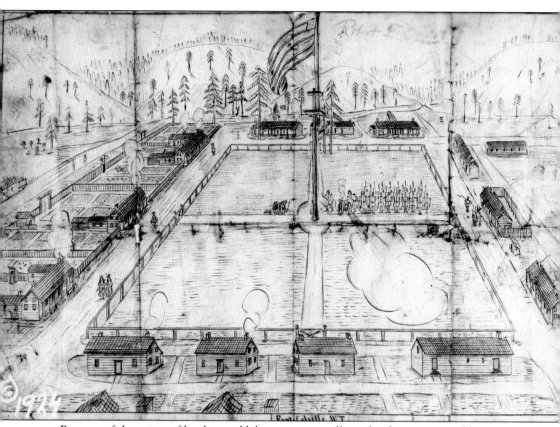

Because of the prices of lumber and labor at a new mill nearby that was owned by a man named Douglas, Captain Lugenbeel decided to build his own sawmill and put a dam on Mill Creek (a branch of the Colville River) about a mile above the fort. The completed fort consisted of a hospital, three officers' barracks, a storehouse, a guardhouse, three company kitchens, four company barracks, a bake house, a blacksmith shop, a granary, a carpentry shop, and eight laundry buildings. On December 12, 1860, a memorial was passed making Harney's Depot a permanent military post of not less than two companies for better protection of the settlers on the Columbia and at the mines in the area. The city of Pinckneyville sprang up just across the creek for trades and supplies. The American Fort Colville closed in 1883. (Courtesy of the Washington State Library.)

Three
TOWNS ALONG THE RIVER

The same year that Cedonia Church was being finished, 1897, the community needed a name. The name "Macedonia" was chosen because Martin Scotton and his friends wanted a name from the Bible. Later, the name was shortened to Cedonia. This picture was taken on October 5, 1907, of the town of Cedonia. The building on the left is Scotton's store; the store's woodshed is visible in the background on the left. The Turner store, on the right, was owned by Agnus and Charles Turner. As early as 1858, George Harvey had chosen a location for a home on the stream called Harvey Creek.

In 1888, Martin Scotton and his wife, Mary Young Scotton, came to be the first permanent family in Cedonia, Washington. Some years later, in 1904 or 1905, Scotton's store was built in the town on land leased from Chris Engelhardt. In 1899, Scotton was sworn in as postmaster. Some early settlers were Joseph and Rebecca Carpenter, Robert and Orpha Dashiel, Sara and Nathan Young, and the Wilburt Rodenbough family. This 1907 photograph of Scotton's store shows, from left to right, Richard Scotton, Martin Scotton, George Scotton, Mary Scotton, and Will Turner. The young Bessie Scotton is standing in front of Turner.

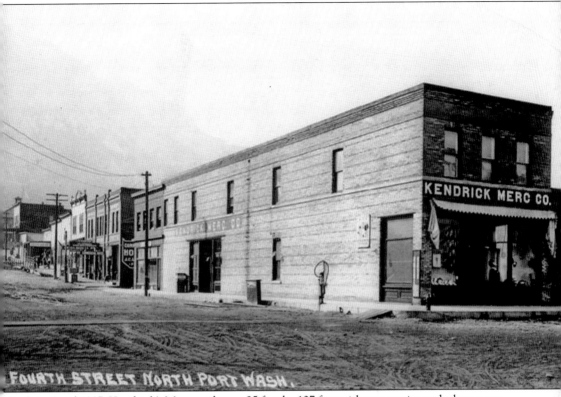

Built in April 1897, Kendrick's Mercantile was 25 feet by 107 feet with two stories and a basement. Located on the corner of Fourth Street and Columbia Avenue in Northport, Washington, Kendrick's Mercantile was originally owned by A.T. Kendrick and later by Northport Corporation. A.T. Kendrick later was a banker at Ritzville and invested $40,000 in the new Mitchem Brothers packing plant in Spokane, Washington. Kendrick's Mercantile was the only store that survived the fire of May 1898. Some of the other Northport shops shown are Beards grocery store, Kuk's pool hall, and Travis Drug Store.

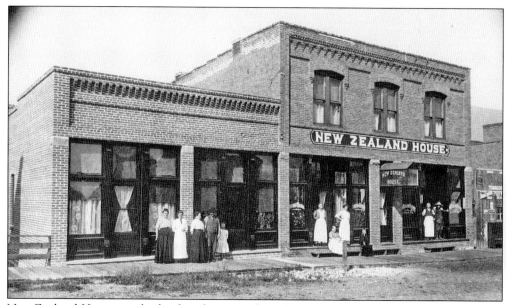

New Zealand House was built after the tragic fire of May 3, 1898, which destroyed all of the buildings of Northport except for Kendrick's Mercantile. Prior to the fire in 1898, Northport had fires in August 1892, May 1893, and March 1896, but the fire of 1898 did the most damage. This a view of the outside of the original New Zealand House and café in Northport. Magnus Wulff was the owner. Pictured from left to right are two unidentified, Helma Williams, Magnus Wulff, two unidentified, ? Wulff, ? Williams, and Carl Edwin (seated boy).

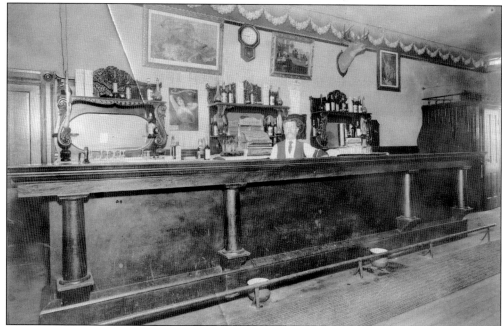

This is an insider's glimpse of the bar of the New Zealand House hotel. The calendar behind the bar shows the year as 1909. Years later, on April 1, 1916, the *Colville Examiner* pointed out that the New Zealand House was one of only two buildings to have been constructed on the burned block. The other was a bank building.

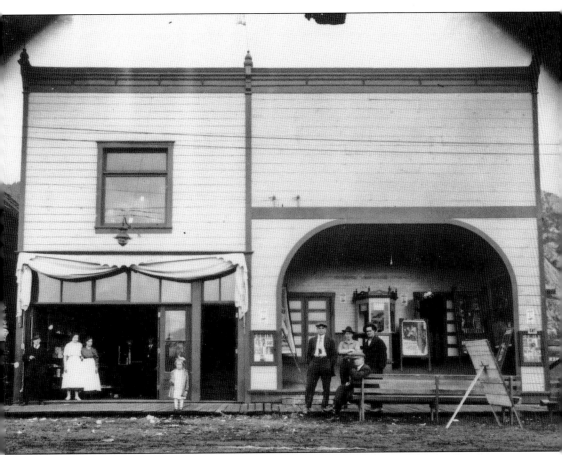

This strip in Northport was home to, from left to right, Joe Tylia's Garage, Beards Feed Store, and the Liberty Theater (later the Liberty Dance Hall). The sign in front of the theater reads "Bijou Tonight, Ben Wilson, In His Own Trap." Benjamin F. Wilson directed and starred in this silent film, released in 1916. The Bijou was opened in November 1915 by B.W. Bickert and Minnie Liebrecht. Wilbur H. Robinson was the second owner.

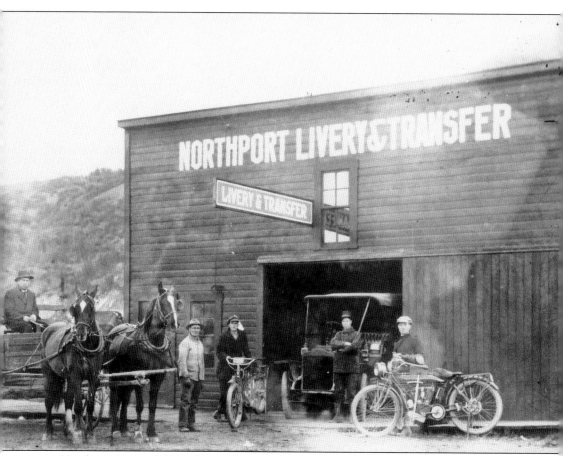

Northport Livery & Transfer was formerly known as McGowan Livery and then was operated by the Shriner brothers, Alf, Earnie, and Fred. Shown here are, from left to right, Earnie (in buggy), George Simpson, unidentified, Wade Thompson, and unidentified. Joe Tylia's auto repair business started in front of the stable in 1921.

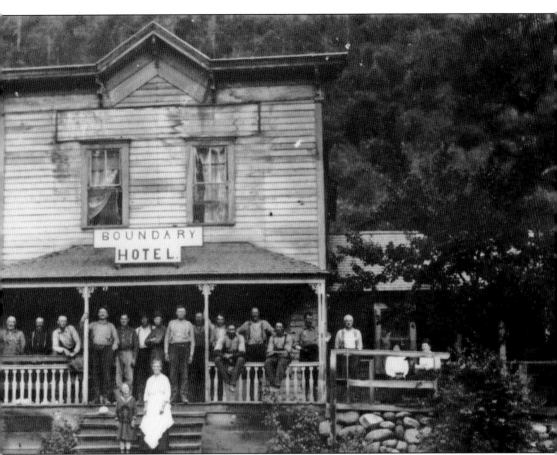

In July 1894, the newspaper stated that Daniel Chase Corbin was planning on extending his railroad from the Little Dalles (below Northport) to Boundary City and that it would more than likely follow the old Roberts trail along the bank of the Columbia River. "Joe Klass was the mine host" of the Boundary Hotel, according to the *Colville Examiner*. On February 25, 1911, the paper stated: " 'Dick', the tobacco chewing deer, is the pet of all who visit Boundary. Dick is a mule deer, this name being given to his class because of the huge ears, resembling those of a mule. The deer is now almost eight months old, and is the property of Mr. and Mrs. Joseph Klass, proprietors of the Boundary Hotel."

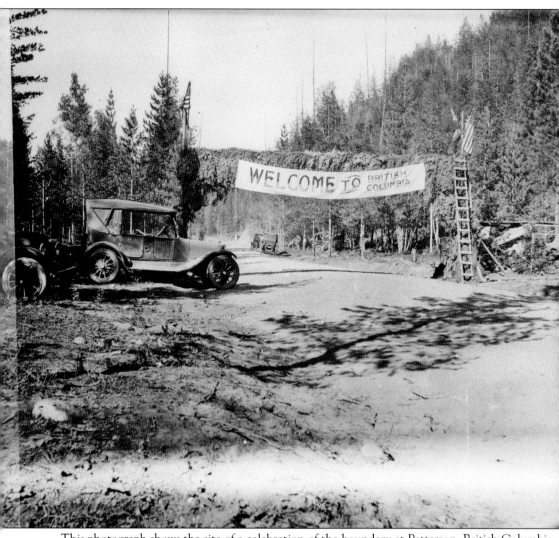

This photograph shows the site of a celebration of the boundary at Patterson, British Columbia. The description on the back of the picture reads: "Site of Celebration. Opening of Spokane & Nelson Highway. Canadian Customs office in middle distance. Speakers stand at ladder; banquet grove to left. Boundary at arch, looking North." Some automobiles of the era are visible.

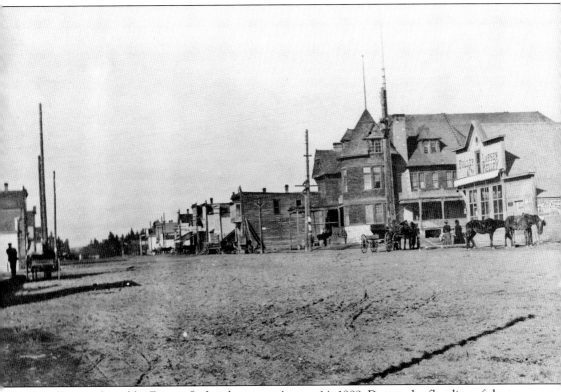

Kettle Falls was platted by Eugene Laframboyse on August 14, 1889. Due to the flooding of the backwater of Coulee Dam, some houses and buildings were moved to what was then Meyers Falls, now called "new" Kettle Falls. In 1888, a small and humble log cabin stood among the somber pines on the present site of Kettle Falls. The cabin had been erected by the Honorable Marcy H. Randall. This man was convinced that such a massive water power must, sooner or later, be utilized, and he squatted on the picturesque bluff overlooking it determined in his conviction that "everything comes to the man who waits." In 1904, this cabin was still there. This street scene is of the "old" Kettle Falls in 1916. On the right are the Rochester Hotel and the Fuller-Larsen-Kelley store with horses and wagons in front.

The articles of incorporation for the old Kettle Falls were dated December 14, 1891. Some of the people listed are T.D. Hayden, sheriff; S.F. Sherwood, clerk; and E.W. Weston, chairman. Additionally, many councilmen, even some from Canada, are on the list.

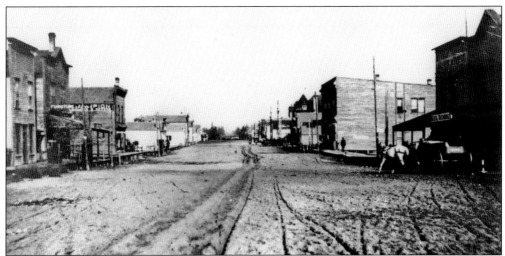

John Goss, a Spokane banker and a hardware wholesaler, was excited about the possibilities that Kettle Falls had and wrote W.B. Aris of Rochester, New York, about the unlimited source of water power along with other shimmering descriptions. When a Rochester capitalist came to visit, Goss showed him the towns in the area, and the Rochester man headed home and started the Rochester & Kettle Falls Land Company. W.B. Aris was its promoter and sold stock while investors paid for improvements to the city. In the spring of 1888, there was but a handful of people, but by the close of 1889, there were hundreds. The main street of old Kettle Falls, Broadway, is seen looking north. Identified buildings are, on the left side, Doyle's Furniture (second from left) and Slagle's Drugstore (third from left); and on the right side, Campbell's store (second from right), Kelley Larsen store (third from right), and Rochester Hotel (fourth from right).

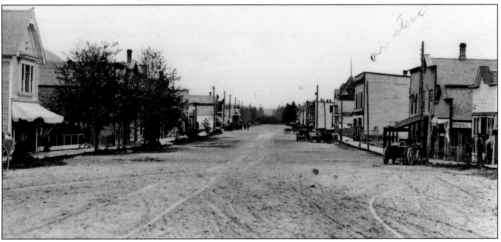

A description in 1891–1892 best describes Kettle Falls in the boom era: "Broad streets and avenues, lined on either side by handsome business blocks, public buildings and princely residences sprung up to attract the attention of the entire state. Twelve miles of twelve foot plank sidewalk was constructed. The handsomest and best appointed hotel west of Helena was located there, where a few months ago the foot of man had not trod. Two churches and a fine school house were erected and a system of water works was established. An electric lighting system, conducted on a magnificent scale, was in operations." When Aris returned from New York with some of the stakeholders, they did not see the potential of the city and refused to advance any more money. The main street of old Kettle Falls is pictured.

This photograph of old Kettle Falls was taken from a neighboring hillside. A promotional advertisement for Kettle Falls described its energy production: "At the Junction of the Colville and Columbia Rivers. One thousand horse power is developed close by on the Colville River, and the falls of the Columbia River, from which the town gets its name are capable of developing two hundred thousand horse power."

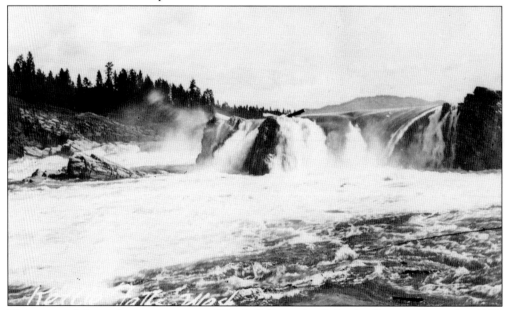

This postcard shows the upper portion of Kettle Falls on the Columbia River in December 1910. For centuries, the falls have lured Indians from hundreds of miles away to catch salmon from this ancient fishery. Native Americans would come from as far as Montana and the Dakotas, bringing buffalo hides and meat to trade. In 1853, there were about 1,000 at the falls. Their name for the falls was Schwan-ate-kou, meaning "deep sounding water."

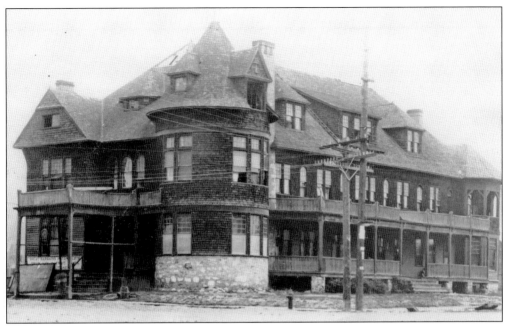

The Rochester Hotel, pictured around 1900, originally had 62 rooms. Work started on the hotel on October 10, 1890, and was completed by April 1, 1891. The hotel was financed by the Rochester & Kettle Falls Land Company and built by C. Ashenfelter. Its furniture was bought in Saginaw, Michigan, at a cost of $9,200.

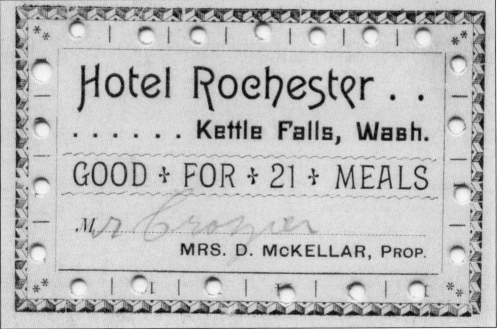

In 1908, Hugh Munro, owner of Hotel Munro, disputed the ownership of Rochester Hotel with W.C. Stayt. It seemed that both men had investment on the property where it stands. The case was brought to superior court and finally resolved in 1910, giving Hugh Munro the property of the Rochester Hotel. Pictured is a meal coupon for the hotel listing Mrs. D. McKellar as proprietor.

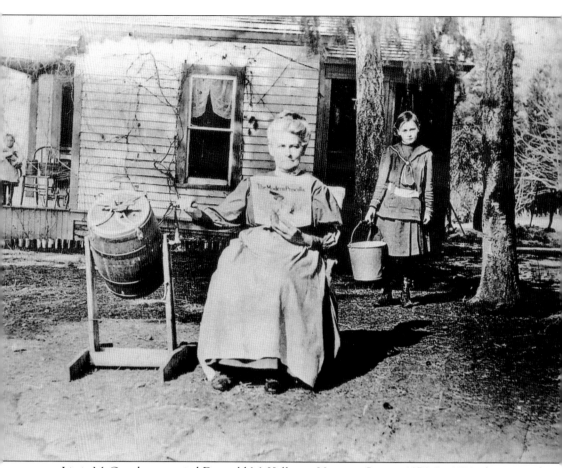

Lizzie McGaughey married Dougald McKellar in Virginia City in 1876. In 1889, they moved to Colville and settled on Mill Creek. Soon after the town was platted, Lizzie became the proprietor of a hotel and boardinghouse. This same building also housed the post office. Dougald set up a livery stable. Lizzie then leased the Rochester Hotel when it became available. Dougald provided service to the mining community of Republic. The barn for the livery was in the back of the Rochester Hotel. Lizzie is seen here in front of her house turning a butter churn. Margaret Edgren is on the porch to the left, and Helen Edgren holds a pail.

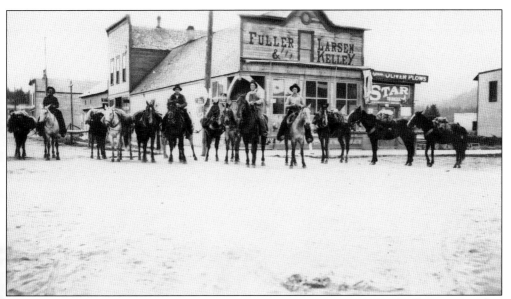

These four men on horseback and their several pack animals pause outside of Fuller-Larsen-Kelley General Store in Old Kettle Falls. The inscription on the back of this photograph reads "F-L-K Headquarters for all sheepmen." The top sign on the post left of center, "To Marcus/Northport," provides a sense of direction.

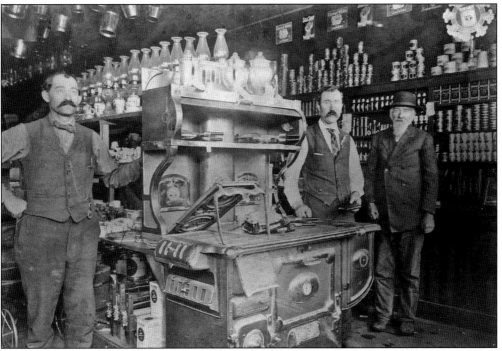

This photograph shows the interior of the Kelley Larsen shop. The store was originally owned by John Fuller, his son-in-law, Charles M. Larsen, and Eber Kelley. Later, it was operated by C.M. Larsen as the Fuller-Larsen-Kelley store. Seen here are a cook stove with kerosene lamps on top, shelves of canned goods, and buckets hanging from the ceiling. From left to right, John Fuller, Charles E. Larsen, and Edmund Blair Growden pose for the camera.

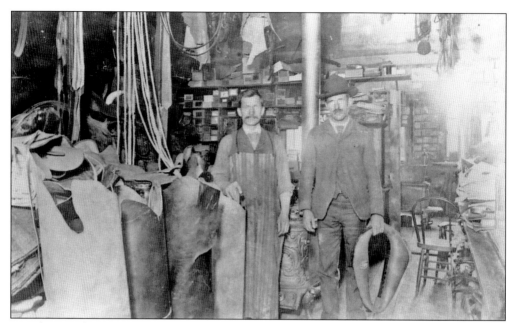

Seen here is the interior of Gustavo Harness Shop, owned by Gustave Weigelt in "old" Kettle Falls. This building was later moved to "new" Kettle Falls and still stands at 565 Meyers Street. Pictured are Gustave Weigelt (left) and Ignatz Staehly.

Gustave Weigelt's family poses for a portrait. From left to right are (first row) Marta C., Virginia L., and Alma M.; (second row) Emile J., Magdalene, Gustave Albert, Johanna, Gustave, and Wilhelmina.

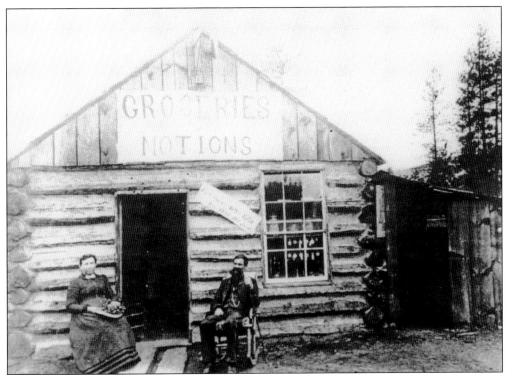

This man and woman pose in front of the first store in Kettle Falls. The sign next to the door reads "First house in Kettle Falls, Nov 1889 Wm Jones." The store sold groceries and notions.

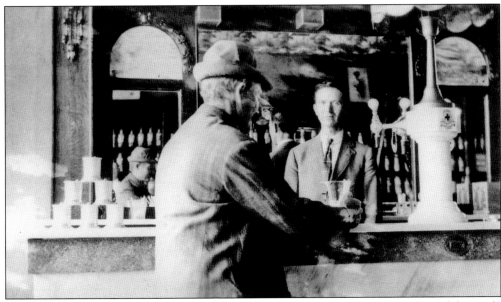

Jeff Slagle stands behind the counter at his drugstore. He was elected vice president of the newly formed athletic club in 1913. Slagle married Lucille Brooks at the home of John and Elizabeth Moore Slagle of Republic in December 1913. Jeff and Lucille had six children, Senora, Robert, Lucille, Frank, Mavis, and Jeff.

The Growdens Camp was an old stagecoach shop. Edmund Bair Growden and his wife, Amanda, operated this station at the confluence of Lane and Sherman Creeks on the road between Kettle Falls and Republic. An old story states that the route crossed the Kettle Range seven or eight miles north of the present highway and went down Lamber Creek.

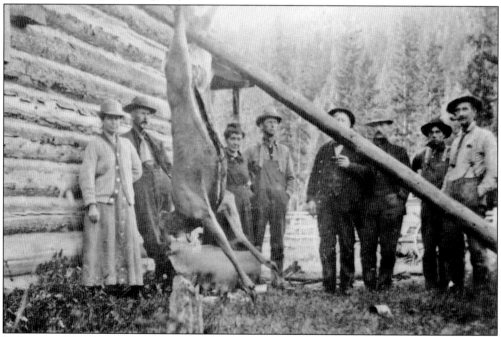

Ledgerwood family members pose in 1910 at Lane Camp, or Camp Growden, located at the confluence of Sherman and Lane Creeks. The deer hanging is a result of their hunting party. Shown here are, from left to right, Mollie Ledgerwood Ferguson, Robert Simon Ledgerwood, Nancy Brown Ledgerwood, Fay Ledgerwood, Ed Ledgerwood, Kit Ledgerwood, Robert Cline, and Joe Ledgerwood.

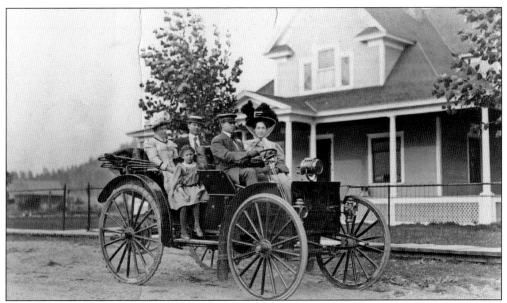

Dr. W.G. Parker rides with his family and friends in the first car in Kettle Falls in 1903. Automobiles of the time looked like a cross between a buggy and a car. Extra amenities, such as windshields, tops, and bumpers, were sold separately. Dr. Parker was a physician and surgeon, and he served as a health officer for the town of Kettle Falls from 1909 to 1910.

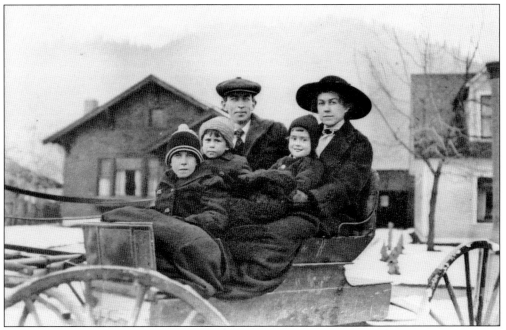

Abe McKellar and his wife, Margaret, and their three children are seated in an open wagon in "old" Kettle Falls. Abe McKellar was born on April 13, 1884. He worked as a postmaster and at a fruit orchard. Visible in the background are two houses and, in the distance, a mountain.

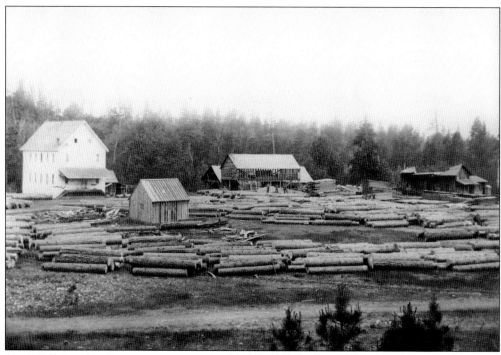

Kettle Falls Lumber Company was owned in 1908 by S.H. Luckett. All kinds of rough and finished lumber and fruit boxes were constantly on hand, available at reasonable prices. In 1914, Luckett leased to the Independent Order of Odd Fellows (IOOF) some lots south of D.H.A. Greenwald's office and then built an automobile repair shop and garage.

As early as 1900, Vern Morris owned this sawmill, located on Copper Flat along the Colville River just south of the town of Kettle Falls. The white building on the far right was a flour mill run by a Mr. Eckert. In 1921, Morris traded in the water-powered mill for the more-advanced, high-powered steam sawmill and planer located near the mouth of the Kettle River (Newhoialpitkwu). The sawmill was originally owned by a Mr. Holston.

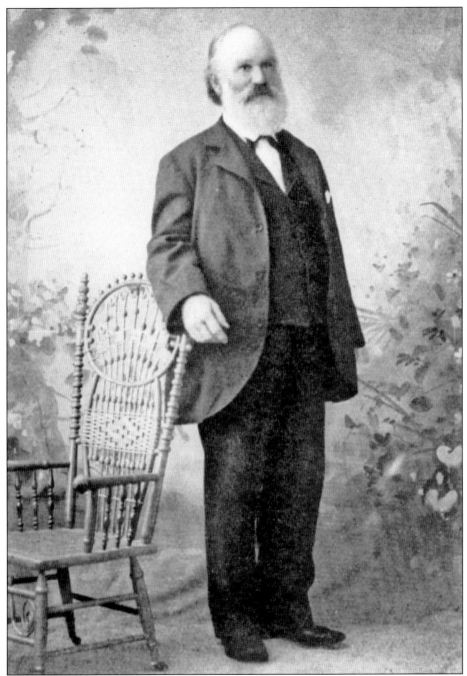

Louther Walden Meyers was born in Ontario, Canada. For several years, he worked as a master cabinetmaker in and around Colville. Meyers married Mary E. Spalding, and they had two sons, Jacob and George. He established a store and trading post at his ranch, three miles east of the falls. In 1866, the falls and the area surrounding them were leased from the Hudson Bay Company to Louther Meyers and his half-brother under the name Louther W. Meyers & Co. The Meyers holding included one-third of the property that would later become the town of Meyers Falls. (Courtesy of Map Metrics.)

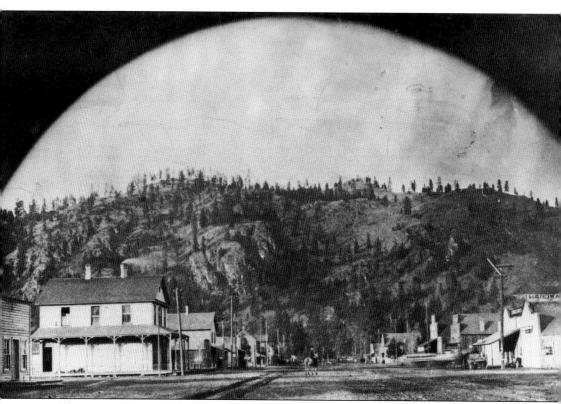

The town of Meyers Falls is viewed through a lens around 1900. This street scene is looking north toward Gold Hill. Some of these buildings still exist in the town, now Kettle Falls. A man on horseback is riding in the middle of the street. In 1910–1911, Meyers Falls' population was 300. The town boasted, "there is a new electric light and power plant at the Falls" and "there is an abundance of power from a fall of 133 feet."

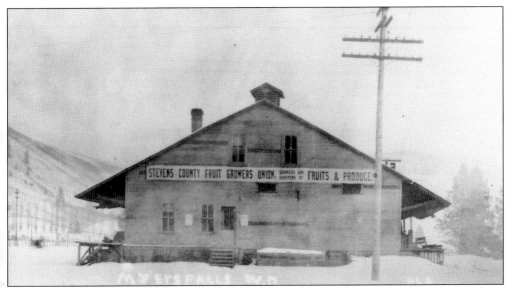

Meyers Falls Fruit House was part of the Universal Fruit Packing Company located on the railroad in Meyers Falls. There was a large number of apple and soft fruit orchards in the Kettle Falls area during the early 1900s. This building still exists, along with houses, organic markets, and other small businesses.

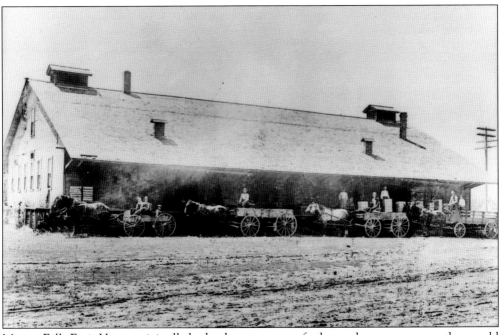

Meyers Falls Fruit House originally had a dugout passage for horse-drawn wagons so they could offload at the floor level. The passenger train station was across the tracks from the warehouse. This photograph shows four horses and carriages lined up. These wagons were likely unloading fruit, probably cherries. C.L. Hansen drove the third wagon in the lineup.

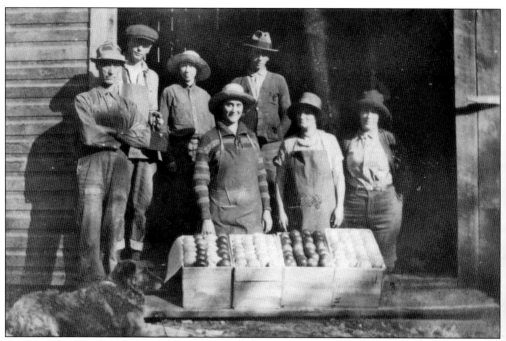

Apple packers and sorters stand outside the Fruit Growers Association Warehouse in Meyers Falls. The town was about three miles east of Kettle Falls and became Kettle Falls during relocation that preceded the flooding of Lake Roosevelt between 1930 and 1935.

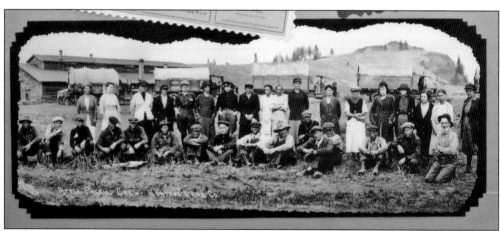

In 1908, the Hunters Land Company was incorporated. It had a very large apple orchard that was located on the original Hunter homestead and the William Haynes farm. It had two packing sheds and employed 150 at harvest time. Mr. Nelson was an early foreman. Later, Jack Llewellyn was manager for many years. An apple packing crew at Hunters Land Company is pictured above.

McKellar Orchard and Ranch was originally purchased by a man named Bernard Lafleur in 1896 and had 160 acres at that time. It was later owned by the McKellar family. It was located south of Kettle Falls at the mouth of Rickey Canyon. Pictured in 1935 are orchardists preparing to spray apple trees at the McKellar Orchard. The wooden spray wagon was pulled by a horse. From left to right are Herman Mellenberger, Abe Gagnon, and Lowell Woods.

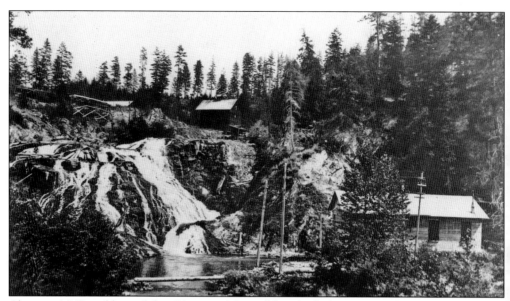

Christine McDonald stated that "the site of the mill [now called Meyers Falls] is where the Indians caught the little fish. In the early days, the Indians came to the little mill to have their wheat and corn ground." The caption with this picture reads: "A 1914 picture of Meyers Falls on the Colville. In the right hand corner is the power house. The log building above was built by my grandfather as a gristmill for the Hudson Bay Company."

This advertisement for a stage and livery company reads: "Fast Stage, Saddle and Pack Horse Line, from Meyers Falls Station to Republic, daily. Passengers, baggage, and express at reasonable rates." This particular card represents a line owned by McKellar, Carter & Co. in Kettle Falls.

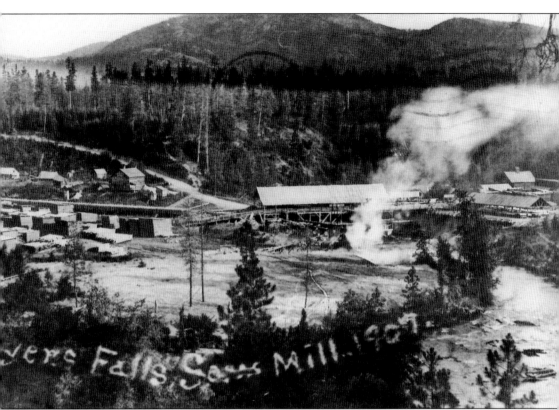

The Meyers Falls Colville Sawmill was located at the top of the Meyers Falls on the Colville River, south of the town of Meyers Falls (now Kettle Falls). This was where the old Hudson Bay mill had been, and the Colville Electric Light Company was built here after this photograph. The mill ownership was passed over to W.H. Gerhart-Bradrick in 1906. This photograph shows the mill in 1907 or 1908.

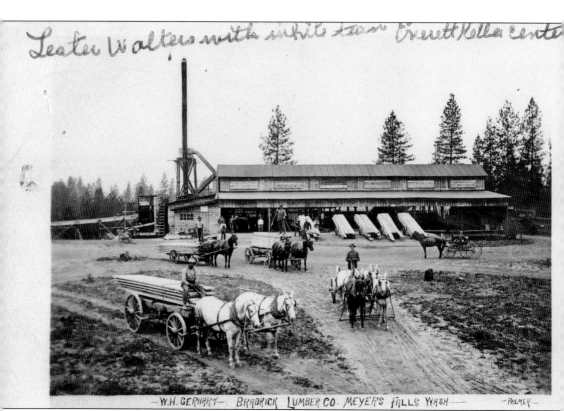

W.H. Gerhart-Bradrick purchased the Meyers Falls Sawmill in December 1906 from Jacob Meyers along with all the remaining lumber and loose logs. In 1907–1908, there was a legal matter as to whether the lumber was all Gerhart-Bradrick's or if one of his workers had accidentally acquired it from Meyers's property. The handwritten caption reads: "Lester Walters with white team Everett Keller center." The photograph shows several teams of horses and wagons pulling loads of new lumber.

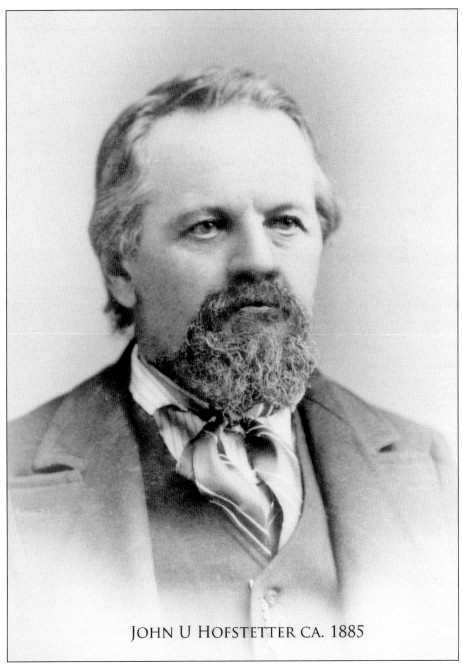

JOHN U HOFSTETTER CA. 1885

John U. Hofstetter, considered by some to be the "Father of Colville," was the first mayor of Colville. In 1861, he was commissioner for Fort Colville, and he was later sheriff. He married Jane Ferrel on September 17, 1863, in Portland, Oregon. Their home for eight years was at "old" Fort Colville. They opened their house to guests. It was not uncommon for them to put a number of straw ticks on the floor for travelers to sleep on when they stopped on their way to and from the fort. There was plenty for all to eat. Prairie chickens, pheasants, and deer could be had for the shooting, and choice fish were abundant in Mill Creek and the Colville River. (Courtesy of Robert E. Webb.)

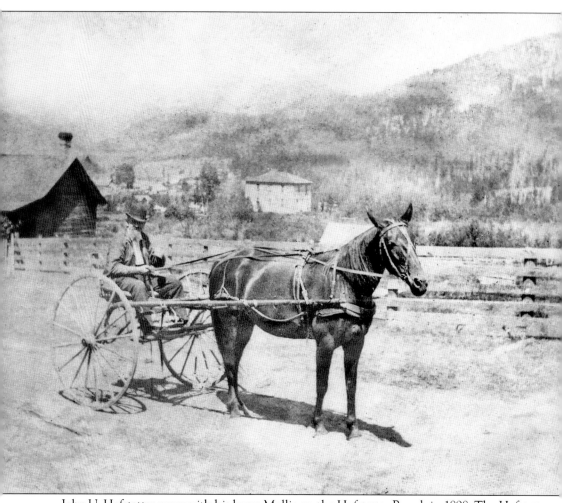

John U. Hofstetter poses with his horse Mollie on the Hofstetter Ranch in 1898. The Hofstetters later gave 40 acres of land for a townsite along with other contributions for a new Colville. The present town of Colville was formerly the Hofstetter Ranch. A preliminary survey for a railroad into the Colville Valley revealed that the contour of the country would not allow for a railroad where the town was. The Hofstetters built a large one-story house on the spot where the Hotel Colville used to stand. (Courtesy of Robert E. Webb.)

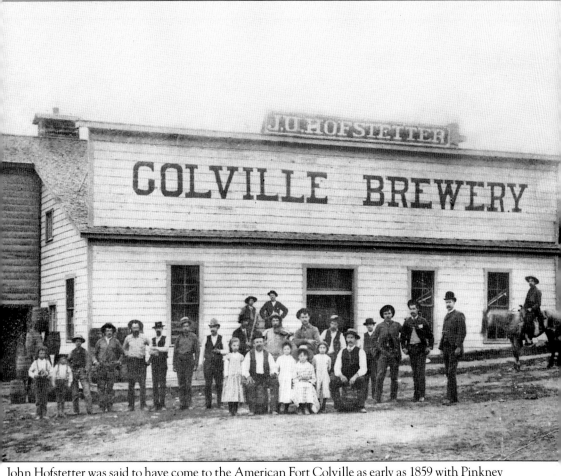

John Hofstetter was said to have come to the American Fort Colville as early as 1859 with Pinkney Lugenbeel. In 1867, House Bill 5 was submitted to have the name of Pinkney City changed to Fort Colville. This photograph shows John U. Hofstetter and others in front of Hofstetter Brewery in Colville, Washington, in 1890. Hofstetter is sitting on a barrel to the left of center. Near him are three young girls and another man sitting on a barrel. Behind Hofstetter is a man playing a fiddle. The sign on top of the building reads "J.U. Hofstetter, Colville Brewery." (Courtesy of Robert E. Webb.)

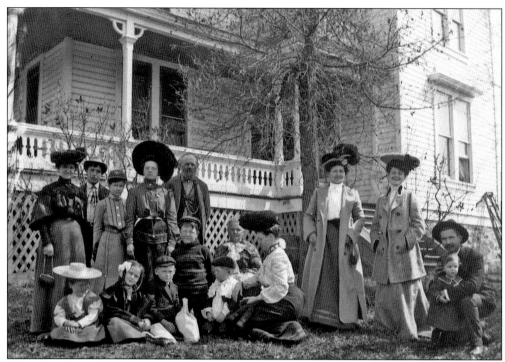

Pictured in 1901 are, from left to right are (first row) Jessie Rice, Dirken girl and boy, Tom Rice, Lillie Rice (Tom's mother), Mrs. Jimmy Dirken, Fannie Silke, Harold (Pete) Silke, and his father; (second row) three unidentified, Clara Hofstetter, John U. Hofstetter, and Jane Hofstetter (sitting). (Courtesy of Robert E. Webb.)

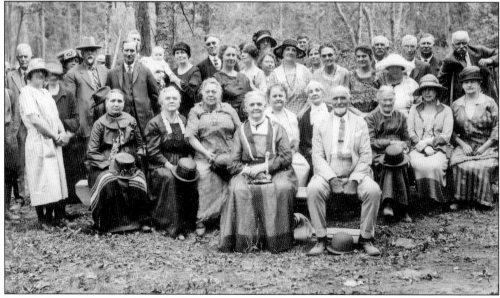

Jane Hofstetter (front, left) and others pose at a 1917 picnic with family and friends. John and Jane Hofstetter had the following children: Lillie L. Rice, Clara Shaver, and Fannie McFarland, all of Colville; W.P. Hofstetter of San Francisco; George Hofstetter of Greenwood; and B.C. and Charles Hofstetter of Bend, Oregon. Hofstetter died in 1906. (Courtesy of Robert E. Webb.)

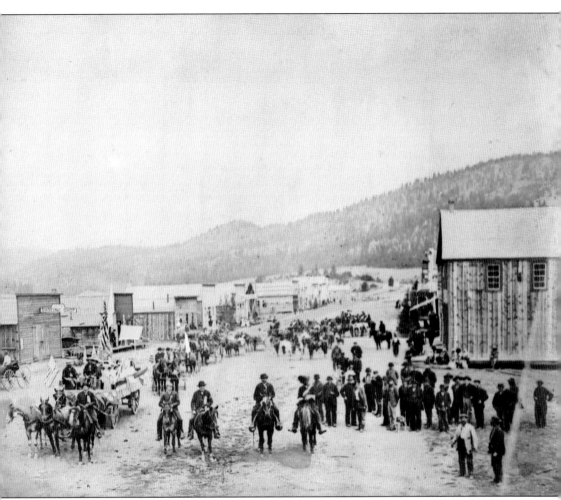

Three years before the Spokane Falls & Northern Railway arrived at the doorstep of Colville, the citizens were enjoying the nation's birthday. Shown here is the town of Colville's Fourth of July celebration in 1886. Drivers are, from left to right, John Hofstetter and French Richard. Riders are, from left to right, C.A. "Kit" Ledgerwood, Al Beuoist, Fred Rice, E.L. Laris, and Gilbert B. Ide. Sitting in the carriage are Mr. and Mrs. Sam Vinson. Visible behind the wagon are L.W. Meyers and his wife. (Courtesy of the Stevens County Historical Society.)

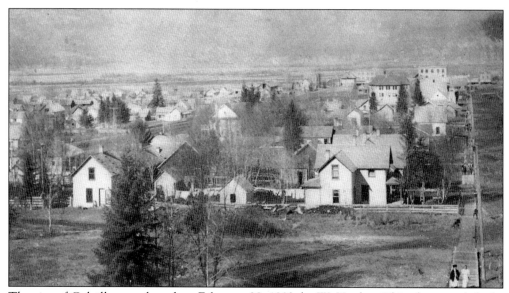

The city of Colville was platted on February 28, 1883, by W. Hooker. This photograph looks to the western part of the city and shows long sidewalks made out of wood, with several people walking on them. Among the several houses are tall buildings; these may be schools. In 1883, the American Fort Colville closed its doors, and the civilians of what was then Pinkney City moved to the present townsite of Colville. In 1889, in preparation for the railroad, a new board sidewalk was hammered down and a brick bank and school were built. (Courtesy of the Stevens County Historical Society.)

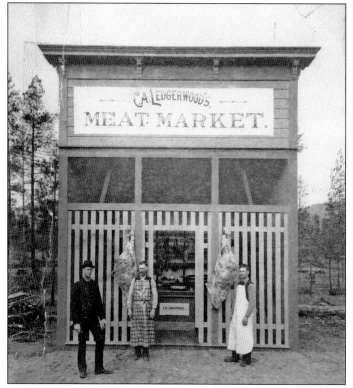

Christopher "Kit" Ledgerwood owned two butcher shops in Kettle Falls and Colville. His father, Thomas Ledgerwood, had crossed the plains in 1852 and married Eliza Lane. Here, three men stand in front of C.A. Ledgerwood's Meat Market in Colville. Two fresh pieces of meat, ready to be sold, hang out front. (Courtesy of the Stevens County Historical Society.)

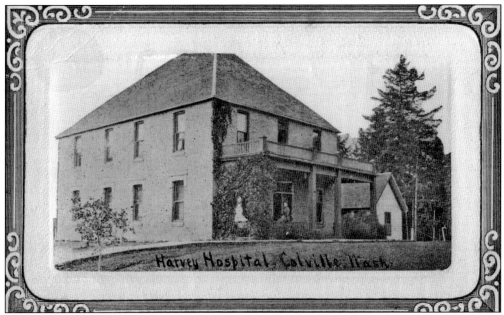

Shown here is Harvey Hospital in Colville. In March 1912, the Stevens County Medical Association was formed. At the time, the association had 22 members. The first elected officers were Dr. Williams Mighil, Dr. Gambee, Dr. L.S. Clark, Dr. A.R. Cook, Dr. W.A. Cartwright, Dr. L.B. Harvey, Dr. J.J. Leiser, and Dr. Olds. (Courtesy of the Stevens County Historical Society.)

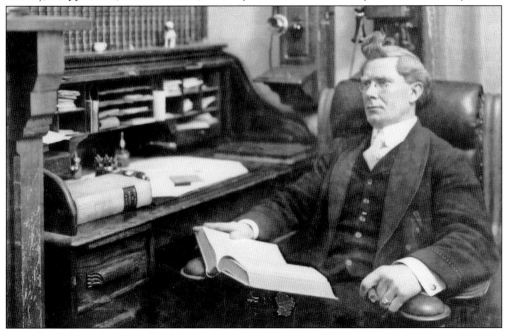

Dr. Lee B. Harvey is seen here at his office in Harvey Hospital. Dr. Harvey left Colville in 1899 with a sheepskin *Gray's Anatomy* under his arm for a medical institute that was established in 1818. He returned two years later with his sheepskin signed. David Lewis then borrowed the old volume and, four years later, returned with his diploma. Ralph Goetter took the very same sheepskin volume in 1911 to study in the medical field. (Courtesy of the Stevens County Historical Society.)

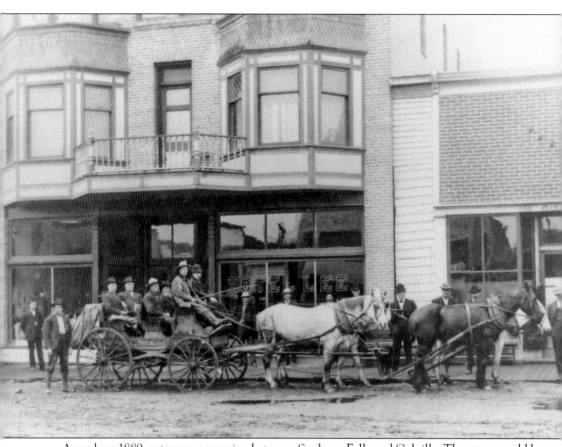

As early as 1889, a stage was running between Spokane Falls and Colville. The stage would leave Spokane at 6:00 a.m. and arrive in Colville the following day at noon. Colville had a couple of different stage lines. One was the Colville & Chronin Stage Line. A.J. Lee was the proprietor of Hotel Lee, which was located between Still and Janet Streets in Colville. The stagecoach in front of Hotel Lee is labeled "Metaline." (Courtesy of the Stevens County Historical Society.)

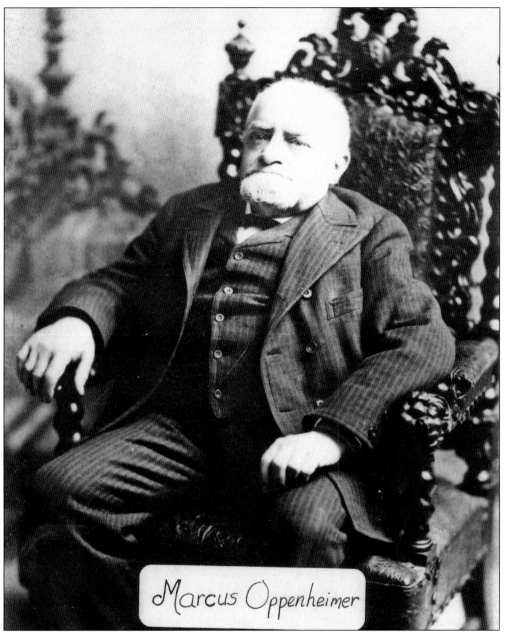

Marcus Oppenheimer crossed the plains in May 1862 from Cincinnati, Ohio, with two drivers and four men: himself, Alec Kaufman, Louis Eckard, and Joseph Oppenheimer, Marcus's brother. Joseph Oppenheimer's children, Ben Burgander, and Carrie Oppenheimer, Marcus Oppenheimer's niece, were also with the party. At one time, the group had 30 or 40 wagons. The first stop was St. Joseph, Missouri before the travelers started across the plains. They arrived in September 1862. (Courtesy of Map Metrics.)

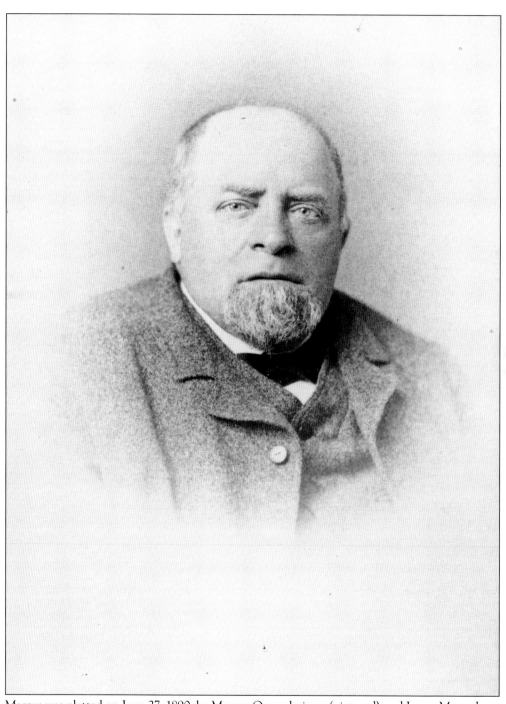

Marcus was platted on June 27, 1890, by Marcus Oppenheimer (pictured) and James Monaghan. However, its history is much older. On July 12, 1859, the British Boundary Commission made its home in Marcus, erecting its own buildings for employee accommodations. For at least two years, while the commission was running survey lines and laying out markers in the untamed mountains of Stevens County, Fort Colville became a happening place. There were several balls and events that lasted until well after the sun came up. (Courtesy of Map Metrics.)

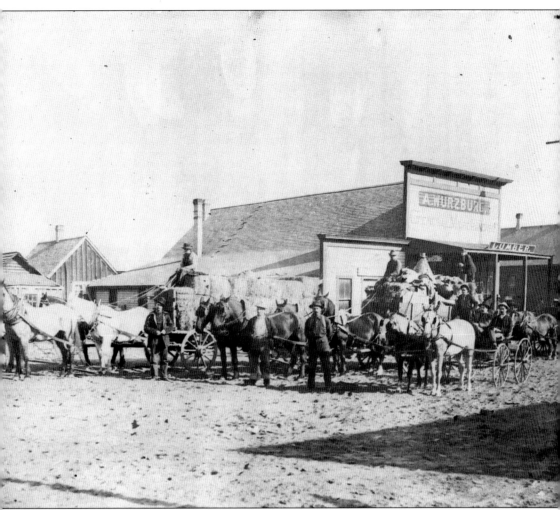

The town of Marcus is seen here during freighting days, with several freight wagons in front of the Wurzburg store. A sign reading "Lumber" is mounted on the front of the store. Marcus was the last American freighting and transportation depot for the rough and anxious miner heading north during the Big Bend Gold Rush in the 1860s in British Columbia. In 1865, the steamboat *Forty-Nine* would traverse from Marcus to the foot of Dalles des Morts or "Death Rapids" at La Porte. In 1898, the *Pioneer* newspaper reported: "Large quantities of whiskey, flour, and other necessities arrived during the week. One day fifteen heavily loaded wagons arrived. Along the wagon road for 85 miles there are freighting teams coming and going. Still it is impossible to clear the blockade at Marcus." In 1898, George Willey had a freighting outfit that frequented Marcus and freighted to the mining towns along the Kettle River Road and later over the Marcus–Republic road. (Courtesy of Map Metrics.)

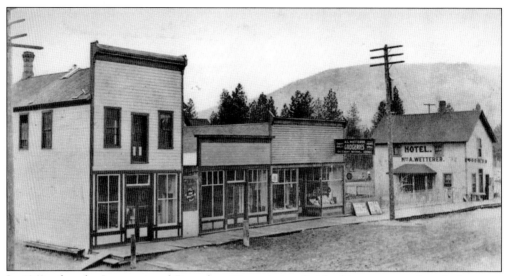

In 1862, after the International Boundary Commission finished its survey and packed up and went home, a man named Ferguson opened a trading store in one of the abandoned buildings, and Vernon Brown also had a store in the vicinity. By 1863, Marcus had bought out Ferguson's business and stared a business with his two brothers, Samuel and Joseph. The town of Marcus was distinct. This photograph shows a hotel and the A.C. Wetterer grocery store. Note the sidewalk made from planks. Located on the Great Northern Railway, it was the first railway division north of Spokane. (Courtesy of Map Metrics.)

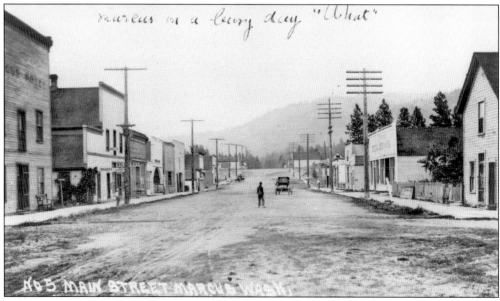

This photograph of Main Street in Marcus, Washington, includes the handwritten caption "Marcus on a busy day." This is a change of pace from 50 years before during the gold fever of the 1860s. The photograph shows a bakery and lunch building, a few cars, and people in the street. Marcus Hotel is seen on the left, along with a billiards hall advertising "Rooms." A meat supply market is on the right. Around 1896, Abraham W. Wurzburg and his wife, Carrie (née Allenburg), moved to Marcus and purchased the store that was owned by Marcus Oppenheimer. (Courtesy of Map Metrics.)

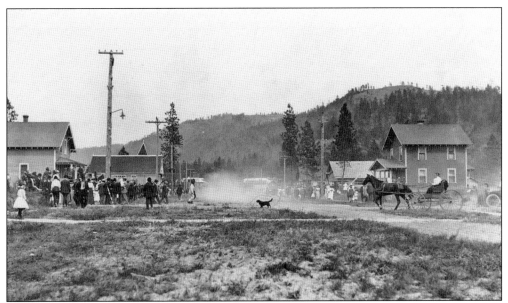

This photograph depicts the town of Marcus's Pioneer Picnic on State Street in 1914. There are several people in the street and more gathered in yards. A woman is driving a horse and buggy, and there may have been a car race. According to Loretta Berglund, who lived across the river from Marcus, "The Presbyterian Church in this picture was later torn down and moved to the new Marcus." Berglund also noted that the stained glass window was donated by Myrtle Moser's parents, the Donnellys. (Courtesy of Map Metrics.)

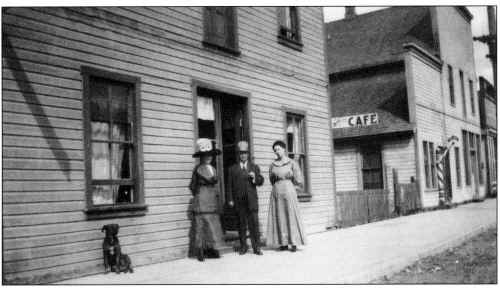

The railroad arrived at Marcus's door on May 20, 1890, and there was a day of celebration as people gathered to see the first train steaming into town. D.C. Corbin's Spokane Falls & Northern Railway was heralded as a boon to the traveler, but to the teamster, the iron horse spelled the beginning of the end. Stella Campbell (left), Bob Campbell (center), and a Miss Obrien stand outside of Stella and Bob Campbell's barbershop in 1913. The Marcus Café is visible in background. (Courtesy of Map Metrics.)

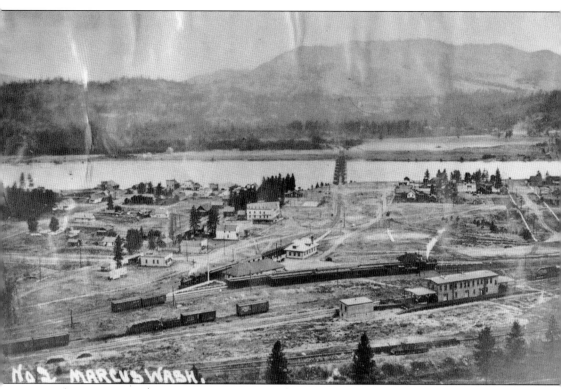

A steam train and a train station are seen in the foreground of this photograph of Marcus. Buildings are visible along the water, and a railroad bridge spans the river. In the years 1910–1911, Marcus had two churches, a Baptist church, led by Rev. H.B Hupp, and a Catholic church, headed by a Father Confrant. The town's hotels at the time were Hotel Royal, with Harry C. Cranke as the proprietor; Hotel Royal Bar, owned by I.T. Peterson; and Hotel Columbia, run by Fred J. Van Buren. The Fisher Bros. bakery and grocery was owned by Charles and Homer Fisher. M.J. Quigley was the inspector at the US immigration office; W.C. Kirk headed up the US commissioner's office; and Thomas P. Murphy and Fred B. McKeehan staffed the US inspector's office. (Courtesy of Map Metrics.)

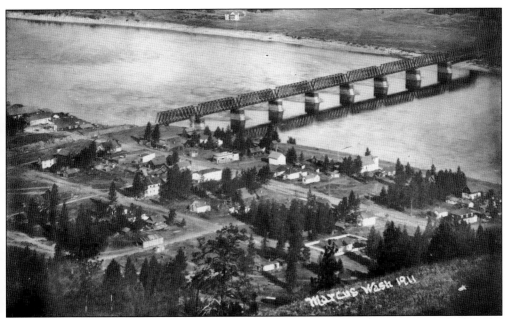

This 1911 bird's-eye view of Marcus features the railroad bridge. Note the house located across the river in the upper center of the photograph. It belonged to Bill Miller, one of the "lucky" prospectors. The railroad bridge was built by the Washington & Great Northern Railroad Company in 1901, when the road was extended from Marcus to Republic. (Courtesy of Map Metrics.)

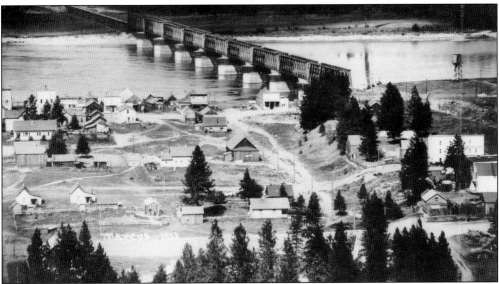

This is a 1911 photograph of Marcus. The town was home to the steamer *Forty-Nine*, piloted by Leonard White. The *Forty-Nine*'s first historic river voyage began on December 9, 1865. It made frequent stops along the shore to gather wood for fuel. It was 114 feet long, 20 feet 4 inches wide, and 5 feet deep with two engines, a 12-and-a-half-inch bore and 4-foot stroke, and 80 horsepower. Christine McDonald, along with Mary Brown, drove the first nail in the steamboat when it was being built. In his report to the US War Department, Henry H. Pierce in 1882 said upon visiting Marcus "and near it's waters lies the warped and rusted machinery of the steamer 49." (Courtesy of Map Metrics.)

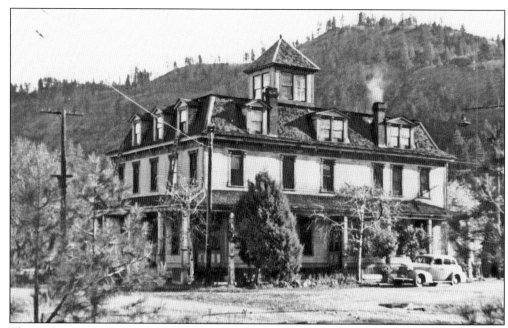

The Corbin's Apartments in Marcus was named for Daniel Chase Corbin. During the 1880s, there was a race to build railroads to important places. Corbin participated in this frenzy over a span of 20 years, building seven feeder railroads, including the Spokane Falls & Northern Railway, which connected with the Canadian Pacific in British Columbia. To get involved in the gold boom, Corbin extended his Spokane Falls line north from Marcus to the rapids of the Dalles des Morts, or "Death Rapids," from which point steamships ran upriver. (Courtesy of Map Metrics.)

The history of the town of Marcus dates from the year 1860, as this is the year the British Boundary Commission built its village of log huts for its headquarters at the site where Marcus later stood. Marcus became an active trading town. The goods were brought in from Walla Walla. The steamer *Forty-Nine* was built in 1865 and navigated the Columbia to Canadian points for 12 to 15 years. Seen here are the British Boundary Commission buildings in Marcus in 1889. (Courtesy of Map Metrics.)

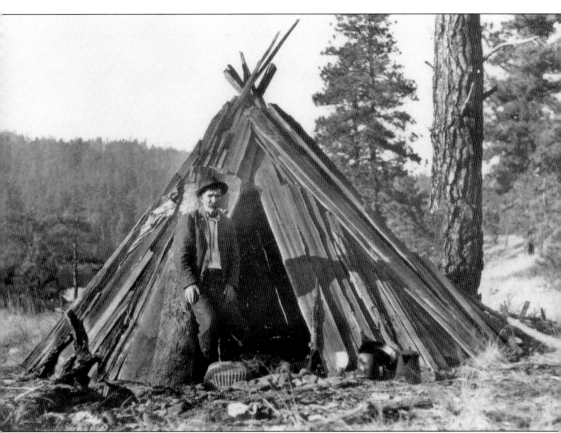

Andrew Edward Pellisser poses beside his teepee at his fishing camp. In 1888, Pellisser, a Marcus resident, was one of the main people who helped build the road from Marcus to the boundary line. This was later called the Kettle River Road. (Courtesy of Map Metrics.)

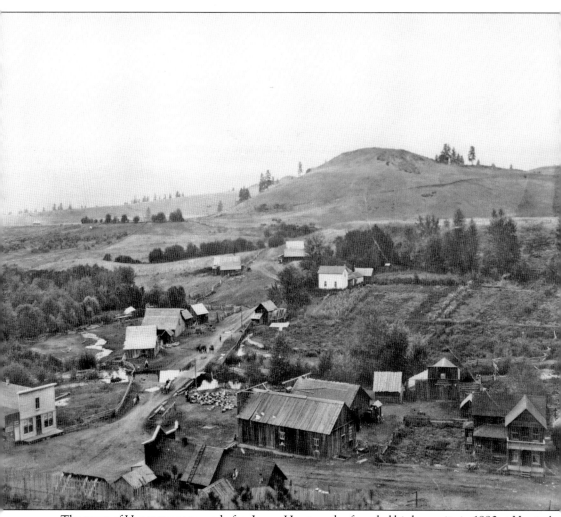

The town of Hunters was named after James Hunter, who founded his homesite in 1880 at Hunter's Creek Falls on the Columbia River. At that time, Hunter was the only white man to settle permanently at that location, and the future town was therefore named for him. Hunter was county superintendent at one time. The first post office was opened in Will Hamilton's home in 1885. In 1890, W.H. Latta platted the townsite. (Courtesy of the Stevens County Historical Society.)

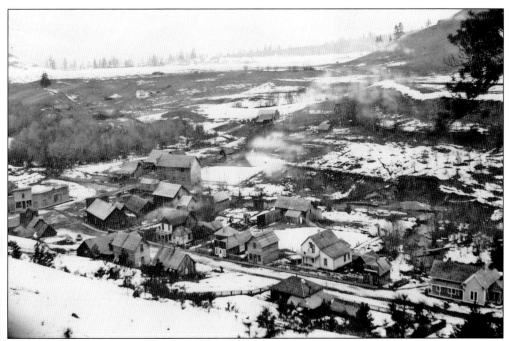

Hunters had a box factory, cable ferry, sawmill, and hotel in 1910–1911. At the time, Hunters was located 40 miles south of Kettle Falls. The town had three stores and a steamer, the *Enterprise*, for transportation. It was the central trading point for the settlers in Harvey and the Fruitland Valley and in the Colville and Spokane Indian Reservations. Hunters' old charm still exists today. (Courtesy of the Stevens County Historical Society.)

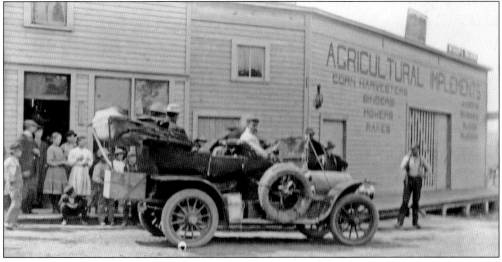

Charles White's store in Hunters advertised "Agricultural implements, corn harvester" on its side. In this photograph, several people are in front of the store admiring the new wheels of the car parked outside. The automobile is loaded with several spare tires and other provisions. Charles White's store was first owned by Frank Dunley and Mr. Smith around 1890–1894. Later, its owners were Ed Houghton, who sold it to Mr. Jacquiz, who then sold it to Mr. McGrath and Charles White. In 1900, after the church in Cedonia was completed, Charles White contributed the bell for it. (Courtesy of the Stevens County Historical Society.)

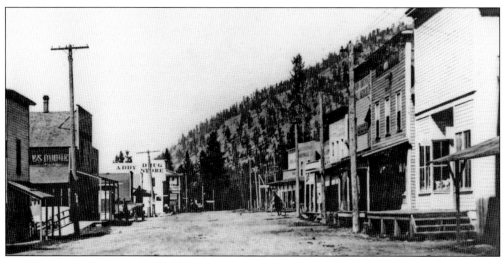

The main street of the pioneer town of Addy looked like this in 1906. Addy Drug Store is in the left background. A building is labeled "E.S. Dudre" on the far left. Addy was founded by Gotlieb Fatzer, who owned a gristmill on the Colville River. In 1890, George Seal established a post office and named the town Addy after his sister. Seal and E.S. Dudrey opened a general store and ran the post office. Dudrey, Seal's brother-in-law, did some milling and in 1898 started another store in town. Fatzer gave the original site of Addy to the Seal family at the time of his death. Mrs. Seal (Nellie A. Anderson) cared for Fatzer in the last year of his life. (Courtesy of the Stevens County Historical Society.)

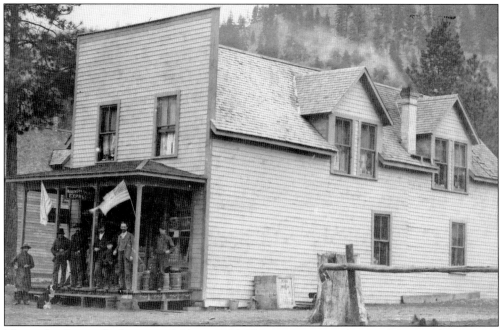

This is the George Seal store in Addy in 1906. The store's sign reads "Northern Pacific Express." Another sign indicates that there is a telephone inside. Several barrels are visible on the porch, and flags are displayed. Standing in front of the store are, from left to right, Addy's blacksmith, two unidentified customers, George Seal, Jack Audrey, ? Anderson, and an unidentified customer. The girls looking out the second-floor window are Irene Seal and Hallie Audrey.

Four

FERRIES, STEAMERS, AND RAILS

An empty ferry is seen here at Ben Camp Ferry in Kettle Falls. The Ben Camp cable ferry crossed the Columbia River. The force of the river's current carried the ferry along the cable from shore to shore. E.F. Warren installed the first ferry across the Columbia River at Kettle Falls in 1891. Subsequently, J.W. Reynolds and, later, D. McKellar owned the boat. It was acquired by Ben Camp Sr. in 1904.

Early cable ferries often used either rope or steel chains, with the latter resulting in the alternate name of chain ferry. Both of these were largely replaced by stronger and more durable wire cable by the late 19th century. Ben Camp perches up on top of his ferry cable tower on the west bank of the Columbia River. This tower held the cable that allowed the ferries to navigate across the Columbia River.

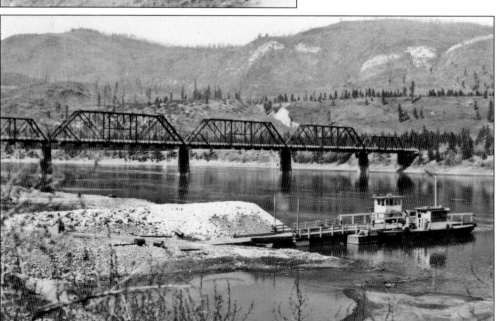

The ferry landing and ferryboat at the old Northport Bridge are shown here before the bridge collapsed. F.M. Davis was one of the ferry operators in 1921. Roads that led to and from the ferry were often very rough. In order to reach the railroad to British Columbia, a traveler would first need to travel to Patterson.

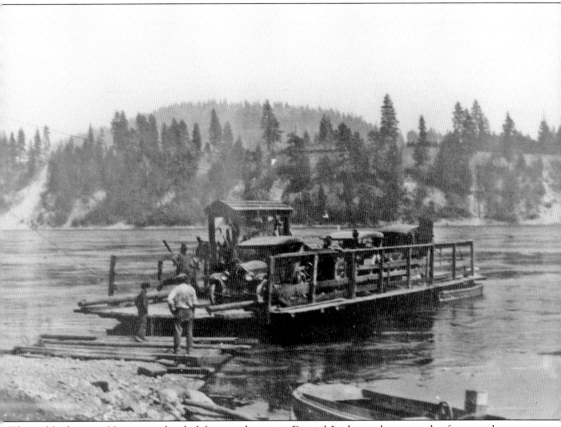

The cable ferry at Hunters is loaded for another trip. Daniel Ladoux also owned a ferry at the mouth of the Kettle River (Newhoialpitkwu). Some of the prices in January 1861 were $5 for a wagon with two animals; $1.50 for a man and horse; 75¢ for each horse or mule; 50¢ for a man on foot, and 20¢ for each head of sheep or swine. The picture shows three cars and a horse and what looks like maybe a buggy pulled by another horse. Hunters was home to Capt. Fred McDermott of the steamer *Enterprise*. (Courtesy of Map Metrics.)

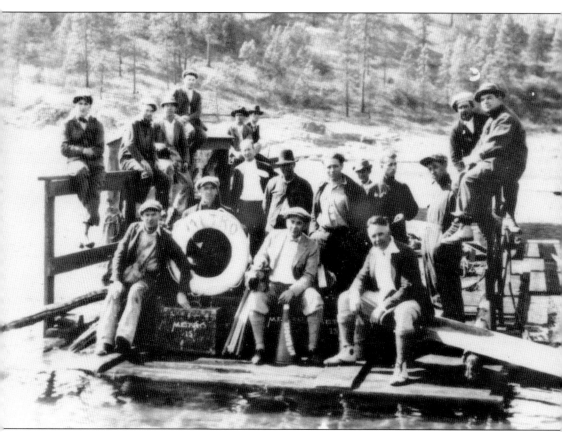

One of the first known ferries at Marcus was built and owned by Charles Miller and Cyrus Hall in 1898. Hall afterwards sold to Miller, who operated it for approximately 10 years. In 1919, the ferry was owned by James Mullen and Clara Hatch. The cable ferry at Marcus carries a film crew, presumably that of Metro-Goldwyn-Mayer. The director may be the man sitting in front with a camera and director's horn. Several men are sitting on equipment boxes labeled "Metro." (Courtesy of Map Metrics.)

Ferries have been in existence on the Columbia River for years. For example, in 1859, a ferry that had been built by the US Boundary Commission the prior year was purchased by the British Boundary Commission to "cross the Columbia of 400 yards several times for frequent communication would be necessary." The cable ferry at Marcus has received two people in a buggy; two men are standing nearby. Note the small boat on the shore. This photograph was taken in 1909. (Courtesy of Map Metrics.)

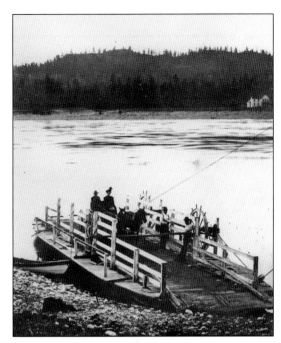

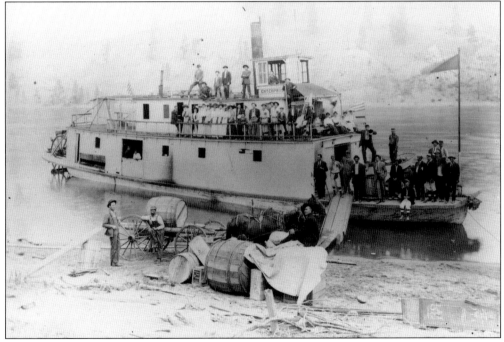

A baseball picnic was held aboard the steamer *Enterprise* on the Columbia River in 1909. The player sitting on the edge of the boat with his feet dangling looks like a member of the McKellar family. The steamer *Enterprise* was one of the smaller steamboats of the Columbia & Okanogan Company's fleet. It was both a passenger and a freight boat. Its schedule in 1909 was: leave Kettle Falls Landing Monday and Friday at 6:00 a.m. for Daisy, Edendale, Gifford, Troy, Covada, Colville Reservation Districts, Hunters, Fruitland, Gerome, Spokane Landing, and intermediate points; return Tuesdays and Saturdays. Its captain was Fred McDermott.

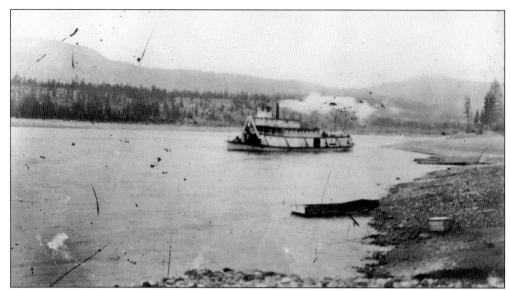

The steamer *Enterprise* passes the Rickey Rapids on the Columbia River, possibly headed south. The *Enterprise* was one of five known steamboats that operated to Kettle Falls. Other steamers were *Spokane*, *Ione*, *Ruth*, and *Red Cloud*. In 1907, the steamer *Enterprise* went aground at Entiat Rapids with Capt. Fred McDermott as commander near where the *Griggs* had wrecked a short time before.

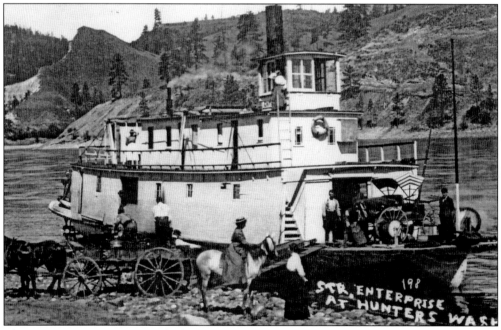

The steamer *Enterprise* is seen docked at Hunters in 1910. The caption reads, "Str. Enterprise at Hunters, Wash." The photograph shows a woman on a horse and a buggy on the steamer. Another woman is standing on the top deck, while men load items using a plank. In 1906, the steamer *Enterprise*, with some government officials and Captain Hansen (an old captain of the Columbia) made a trip down the Columbia River as far as Kettle Falls. The object was rumored to be for the inspection of dangerous points along the river to determine where to blast rocks.

Rickey Rapids, also known as Thompson or Grand Rapids, was the northernmost terminal for the boats of the late 19th and early 20th centuries. It was located on the Columbia River below Kettle Falls. Steamboats coming up the river stopped at this point. John Rickey, one of the earlier settlers of Stevens County in 1874, operated a steamboat from the Rickey Rapids to Fort Spokane. He also started Rickey Creek Orchard.

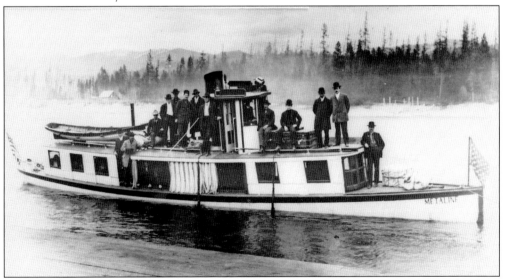

The *Metaline* was built at Newport, Idaho, in 1895. It was piloted by Capt. A.C. Flanders from 1906–1907 until possibly 1910–1911, when the railroad came to Metaline Falls. The name Metaline was probably chosen because the area is surrounded by mineral-rich lands. Metaline was originally called Pend Orielle. (Courtesy of Metaline, Metaline Falls Library.)

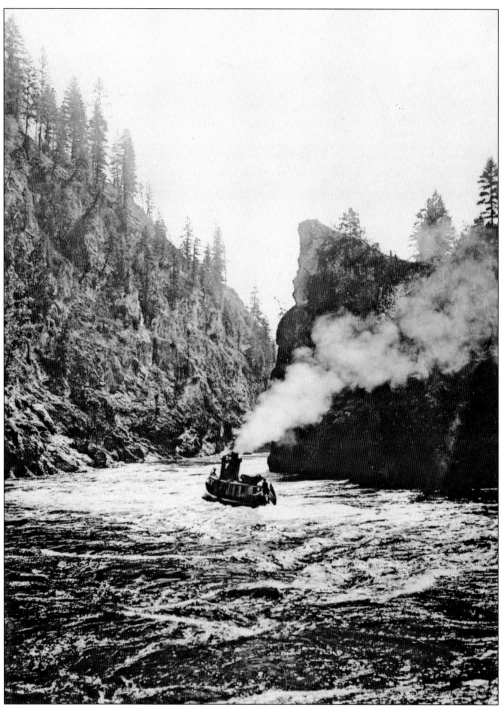

The steamer *Metaline* is shown here passing through Box Canyon. According to Jack Perkins, a wood supplier for the burner of the 62-foot *Metaline*, *Nancy* and *Zelma* went through the canyon along with *Metaline* as it hauled items for the Le Roi plant being built. Eventually, *Metaline* was converted to a gasoline-run ferry. (Courtesy of Metaline, Metaline Falls Library.)

The Fruitland Irrigation Company used this flume as part of its operations. Water was taken from the Colville River near Meyers Falls and carried by flume and ditch nine miles south of Kettle Falls to farms and orchards. This photograph was taken in 1908. The company was created in 1905.

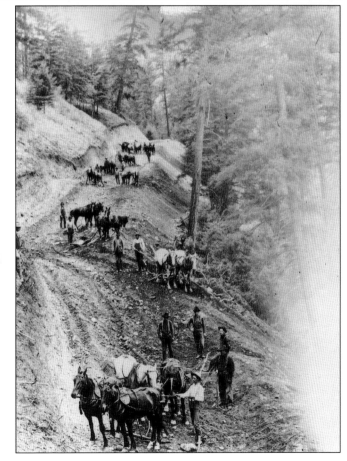

Construction of the Fruitland Irrigation Company ditch began in 1907 and was completed in November 1908. This photograph shows eight or nine teams of horses and men. This location is probably close to where water was to be taken from the Colville River. The men identified in the foreground are Lowell Woods, Budd McKellar, John Edgren, and Abe McKellar.

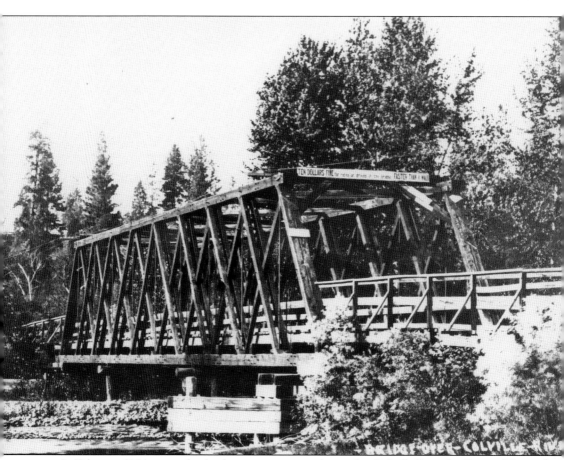

In February 1894, a new footbridge was constructed over the Colville River by George Meyers for the accommodation of the schoolchildren who had been crossing on ice all winter and because to the old bridge had been ruined by flooding the previous year. This bridge across the Colville River was located approximately three miles south of Kettle Falls. A $10 fine was assessed for riding or driving on the bridge faster than at a walker's pace. The old wooden bridge crossed the Colville River between Kettle Falls and the orchards on the river. This bridge predates the automobile era.

This photograph shows the three bridges that crossed the Columbia River at Kettle Falls: the new highway and railroad bridges are partially completed. Below the new bridges was the old one from 1929 that was later removed. Also shown are both the lower and upper Kettle Falls.

This photograph shows the original highway bridge over Kettle Falls on the Columbia River. This bridge was completed in 1929 and dedicated in 1930. Built by J.H. Tillman Company of Santa Cruz, California, the bridge was 1,219 feet in length between the approaches and 145 feet above the level of low water. A Ford truck carrying bridge material and driven by a construction employee crossed the new bridge on October 30, 1929. The bridge was opened to traffic on November 1, 1929.

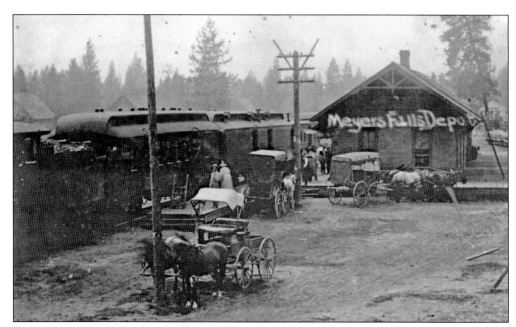

On May 23, 1889, the Spokane Falls & Northern rolled into town carrying as its cargo locomotives no. 310 and no. 311, and on October 18, 1889, a Sunday about noon, the tracks were laid to the new frame depot in Colville that cost about $1,525 to built. A trainload of Spokane citizens were also on board who piled into construction cars in Chewelah. The Spokane Falls & Northern Railway depot at Meyers Falls later became part of the Great Northern Railroad. This photograph shows the depot, a passenger train at the station, and several horse-drawn buggies, including the one from the Rochester Hotel in Kettle Falls.

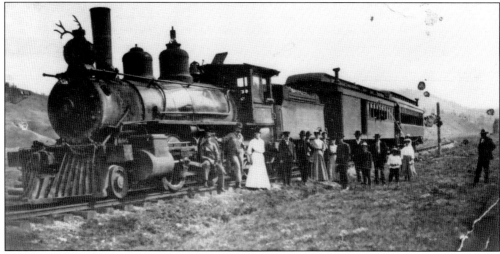

The final survey for the Spokane Falls to Colville Road followed the old Colville trail and wagon road. In 1890, the town of Myers Falls was platted, and the newly constructed railroad ran right through the town to Colville. The route was serpentine, so the men who ran the trains nicknamed the road "the Snake." In 1898, D.C. Corbin sold the Spokane Falls & Northern Railway to the Great Northern Railroad. East of Meyers Falls (now Kettle Falls) is a train with a deer rack on top, a conductor, and several people. The train has the number 3 on it and a passenger train attached.

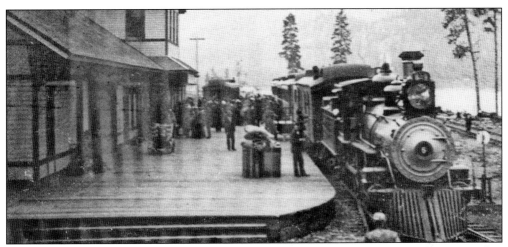

The Spokane Falls & Northern Railway was extended to Northport in the fall of 1892. Sunday, September 18, was the eventful day the railroad reached the town, and E.J. Roberts, the energetic chief engineer of the Spokane Falls & Northern, could be seen in a long duster and a regulation broad Rommel army hat walking with slow and majestic tread, giving his orders in a clear and forcible voice to a large crowd of men who were following him putting ties in their proper places and laying rails, with the construction train moving slowly behind. A boxcar was used for a train depot until a building could be constructed. In 1910–1911, D.W. Williams was an agent, and the depot was located on Front Avenue. The Great Northern Telegraph Co. was located in the same building. The Spokane Falls & Northern No. 5 is pictured arriving at the Northport depot on June 15, 1897.

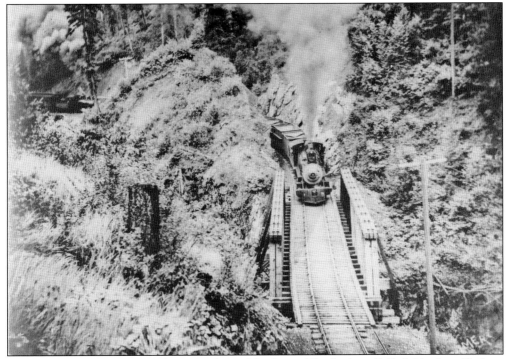

This is the railroad crossing at Sheep Creek near Northport. The Spokane Falls & Northern Railway was called "the Snake" by its builder, D.C. Corbin. Trains would run at 16 miles per hour.

Northport was referred to as the terminal city, it being the division point for three railroads, all of which belonged to the Great Northern system. These roads were the Spokane Falls & Northern, built in Northport in 1892; the Nelson & Fort Shepard from Northport to Nelson, completed in 1893; and the Columbia & Red Mountain between Northport and Rossland, built in 1897. These two men are standing on the platform of the Northport railroad depot around 1890. The conductor appears be on the left. In 1908, Thomas Moore was an agent at Northport for the Spokane Falls & Northern Railway.

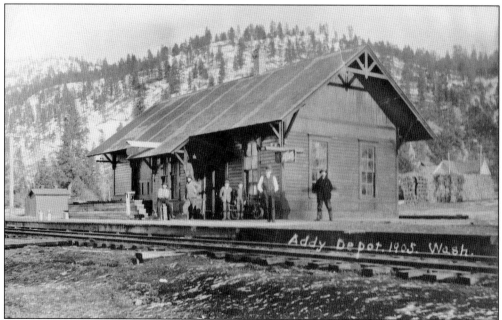

The Addy train depot is pictured here in 1905. There is snow on the ground. The sign on the side of the depot reads "Northern Railroad." Two young boys and three men are standing outside the station. Addy never officially boomed, but it grew rapidly in 1898–1900, when it became a prime railroad shipping point for the Le Roi mine in Rossland.

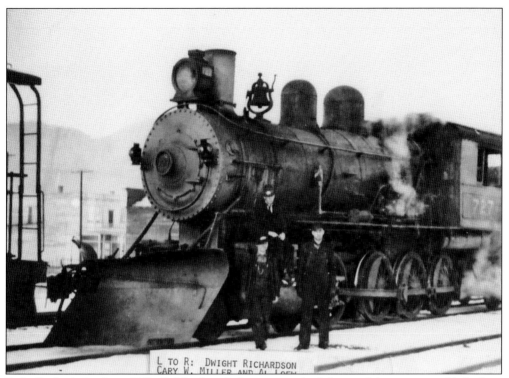

D.C. Corbin's Spokane Falls & Northern's first train schedule into Marcus was published on March 29, 1890. Marcus was an important terminal and junction with a roundhouse and lines running to Rossland; Nelson, British Columbia; Republic; Oroville; and Spokane. Heavy ice on the Columbia River during the winter of 1916 buckled the railroad bridge at Marcus. The year 1894 brought the great flood of the Columbia River, which washed out some miles of the railroad between Marcus and the Boundary Line, causing very heavy damage. Posing with train no. 727 in Marcus are Dwight Richardson (left), Cary W. Miller (center), and A.L. Loew. It appears that the train has a snow shovel on the front. Some store buildings are visible in the background.

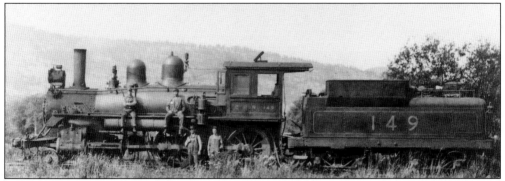

Canadian Pacific Railroad train no. 149 is stopped, probably somewhere near Patterson. Posing in front of the train are four men. This photograph was taken in 1905. In 1893, the first American railway arrived in southern British Columbia, reaching the outskirts of Nelson from Spokane. It was the creation of entrepreneur D.C. Corbin. Corbin built a second rail line into southern British Columbia, this one extending to Rossland from Northport, Washington. In 1898, James Jerome Hill acquired this line. In 1904, Corbin felt that Spokane was in need of a connection with the Canadian Pacific Railroad.

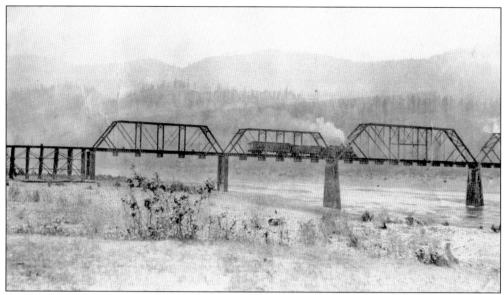

A steam locomotive moves over the bridge at Northport. A story taken from the *Colville Examiner* related a curious incident: "In the year 1919 finding the ferry they're not being operated went to great northern railway bridge and effected a crossing with his auto on reaching the south approach he found it necessary to build a temporary floor with planks gathered from the right of way, but did not remove them after they had served the purpose."

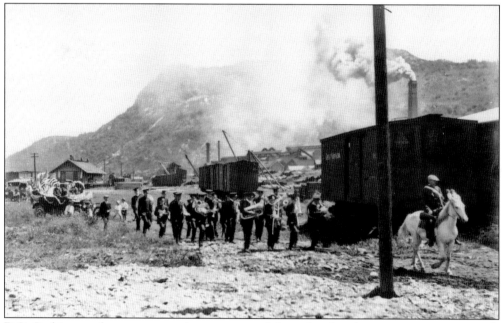

D.C. Corbin was the promoter and constructor of the railroad and went into a contract with Northport editor and publisher W.P. Hughes to built the town of Northport. Another event took place on the nation's birthday in 1892 in Northport, when Hughes and his printer and C.F. Murphy, soon to be editor of the *Northport Republican*, brought the mining smelter in by ox teams to treat the ores from the Le Roi gold mine in Rossland, British Columbia. Shown here is a Fourth of July parade at the railroad station and freight depot in Northport, Washington.

Five
COMMUNITY LIFE

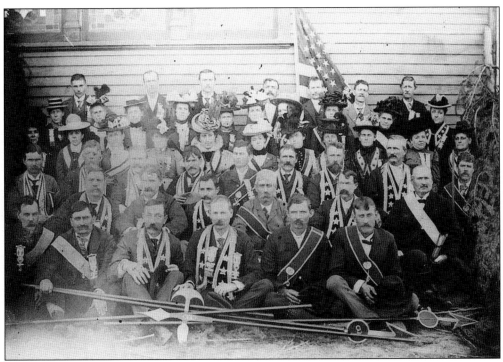

This c. 1902 photograph of the International Order of Odd Fellows and Rebekah Lodges appears to have been taken next to the Presbyterian church in "old" Kettle Falls. Men are wearing their sashes indicating status within the organization. Per the *Colville Examiner* of January 23, 1909, lodge officers were "Kettle Falls IOOF Post 143–Gustav Weigelt, N.G.; F. Yarnell, V.G.; Lee Liewellyn, secretary; E.J. Kelly, treasurer. Kettle Falls Rebekahs–Mrs. L.H. Liewellyn, N.G.; Mrs. Bessie Wood, V.G.; Mrs. Elsie Smith, secretary; Mrs. Hipple, treasurer; Mrs. Lizzie McKeller, chaplain; Mrs. Bert Williams, past grand; Mrs. Mary M. Fish, R.S.N.G.; Mrs. Ed Currey, inside guardian; Mrs. Gustav Weigelt, outside guardian; Miss Minne Rother, warden; Mrs. Bertha Johnson, conductress."

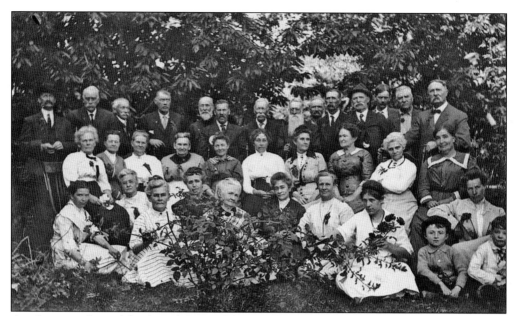

Auxiliary members of the Grand Army of the Republic Woman's Relief Corps are photographed while attending a meeting at "Grandma Lizzie" McKellar's. Those pictured include Bess Woods, Elizabeth "Lizzie" McKellar, Annie Smith, Liz Stafford, Mrs. Bertie Williams, Ted Little, Dick Woods, Charles Heath, Lee Llewellyn, Mrs. Charles Little, Charles Little, and Douglas McKellar.

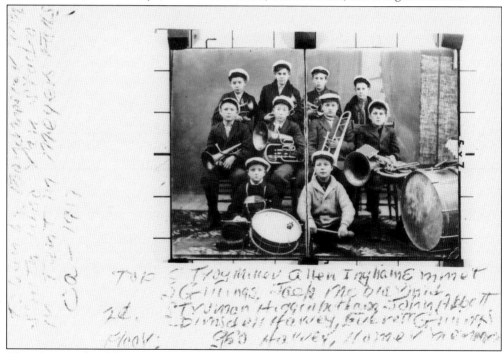

This photograph of the Meyers Falls band was taken by bandmaster William Smith, who ran a studio in a tent in Meyers Falls. The photograph was possibly taken in 1917. From left to right are (first row) George Harvey and Homer ?; (second row) Truman Higgenbotham, John Abbott, Dimsdell Harvey, and Everett ?; (third row) Troy Miller, Allan Ingham, Emmett ?, and Joseph ?.

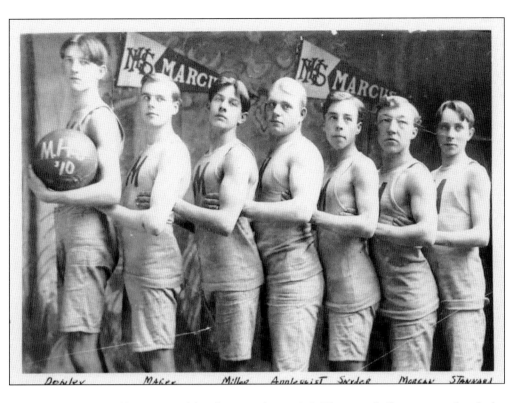

The Marcus basketball team posed for photographs in 1910. The team ball was printed with the high school initials, M.H.S. Posing in the photograph below are, from left to right, (first row) ? Miller, Ben Donley (brother of Myrtle Mosier), ? Snyder, and ? Stannard; (second row) ? Magee, Tuffy Morgan, Henry "Hack" Applequist, and ? Beardsley, the coach.

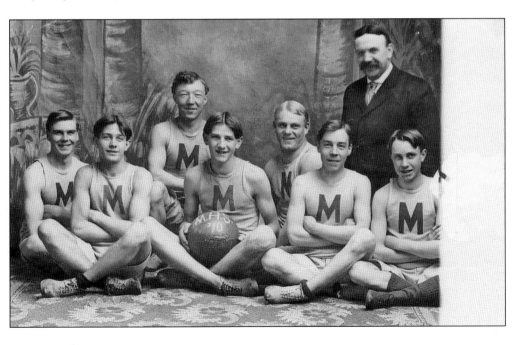

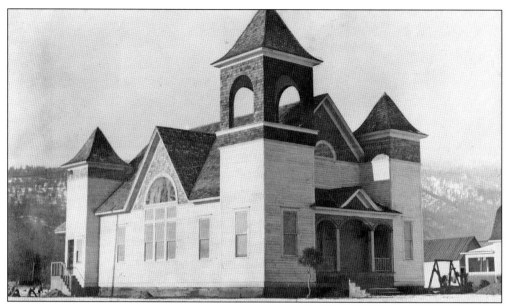

Kettle Falls Baptist Church was dedicated on October 23, 1910. About two years earlier, on March 22, 1908, some people met in the Presbyterian church and took preliminary steps for the organization. Then, on March 27, 1908, the first organized meeting of the Baptist church was held in Fish Hall. Charter members of the church were Mr. and Mrs. W.D. Lee, Mr. and Mrs. M.L. Morton, Mr. Potts, Mr. and Mrs. F.H. Holcomb, and Arthur Holcomb. Rev. C.S. Treadwell, the Baptist church's first pastor, was also instrumental in the organization of the church. Construction of the church was started on March 1910.

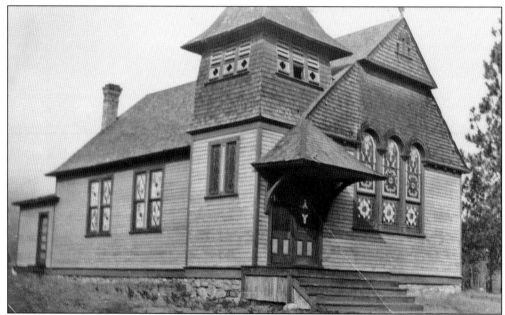

The Presbyterian Old Church was located in Kettle Falls. On October 16, 1891, the *Pullman Herald* reported: "The largest church bell, and the second in Stevens County, has just been placed in the belfry of the Presbyterian church in Kettle Falls. Its weight is 405 pounds. The other bell, the first to be placed in position, is in the church at the Mission."

List of Children of the legal school age in District No 1 Stevens County W.T.

#	Name	age	#	Name	age
1	Thomas Hall	12	16	Manuel Lafluer	10
2	Charles "	10	17	Joachim "	7
3	John "	8	18	Ellinor "	5
4	Amelia "	6	19	Peter Merchant	9
5	Mary Thebido	17	20	Louis "	19
6	Joseph Merchant	15	21	Benj "	14
7	Sophia "	4	22	Adeline Jondron	15
8	Alex Jondron	13	23	James "	12
9	Antoine "	9	24	Marcelline "	7
10	Christine Fry	11	25	Catherine Fry	8
11	Eliza Livingstone	8	26	Christine Pikin	7
12	Peter Pikin	6	27	Elijah B Graybill	8
13	George Myers	18	28	& Sis	
14	Amy Boyd	5	29	Charles Brown	
15	William Baylie		30	William Cragie	

The school has been kept 33 days this fall, and as soon as the children recover from the sickness now among them will again open and continue from 2 to 5 months the Books used are the National Series of Readers and Spellers.

This is a portion of school records at Fort Colville in 1877. Shown here is page 2 of the Register of School District 1, Old Fort. Among the names listed here are the following: Thomas Hall, Charles Hall, Amelia Hall, Manuel Lafluer, Joachim Lafluer, Peter Marchant (Marchand), Benjamin Marchant (Marchant), James Gandre, Antoine Gandre, and Alexander Gandre. The teacher is William Moore. (Courtesy of Map Metrics.)

Register of School District Nº 1.

Names.	No. of days taught
Thomas Hall	
Charles "	November 1877. 14 days
Amelia "	Decr. " 21 "
John "	January 1878. 23 "
Manuel Lafleur	Feb.y " 4
Joachim "	'62
Peter Marchant	
Benj." "	
Joseph "	
James Gandro	
Antoine "	
Alexander "	

Remarks.

The attendance during the whole Term has been remarkably good, being the full number almost uninterruptedly up to the last day of the Term. Strict discipline was maintained throughout with satisfactory results, and the progress made was encouraging both to Teacher and taught.

Fort Colville
Feb.y 6th 1878.

William Moore
Teacher School District Nº 1

Another page from the 1877 school records at Fort Colville lists the students and the number of days taught, along with teacher William Moore's remarks. (Courtesy of Map Metrics.)

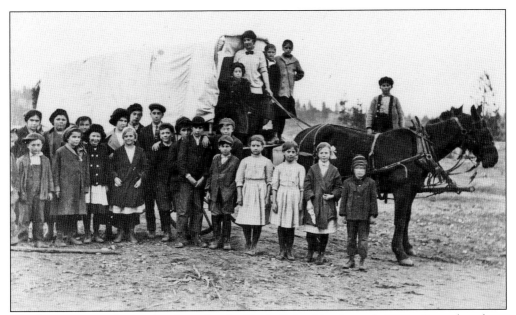

This buggy was used as a school van for the Kettle School in the early 1900s. Several students are standing beside the canvas-covered wagon, which is pulled by two horses. Irene Marty was the driver. Herman Mellenberger is on the tongue of the van, and Sylvia Mellenberger Worley is on the back.

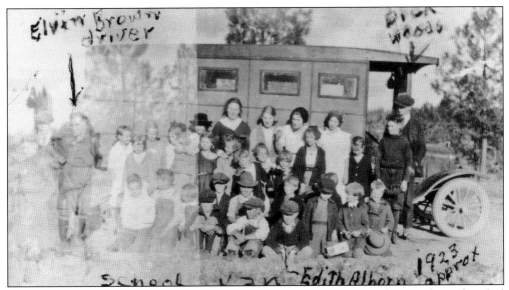

This photograph of an early motorized Kettle School van was taken around 1923. Those identified in the photograph are Elvin Brown, driver Dick Woods, and Edith Alborn. The term "bus" did not come into use until later.

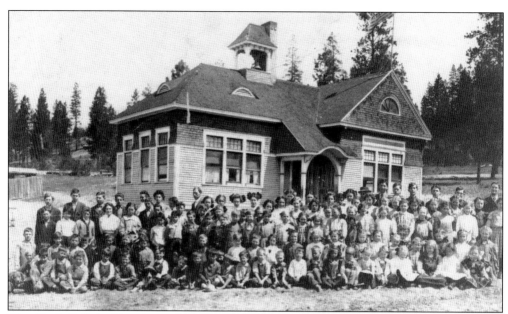

This Kettle Falls building housed all grades from kindergarten through 12th before 1905. Note the outhouse on the left. The bell was mounted on a marble rock pedestal in front of the Kettle Falls High School.

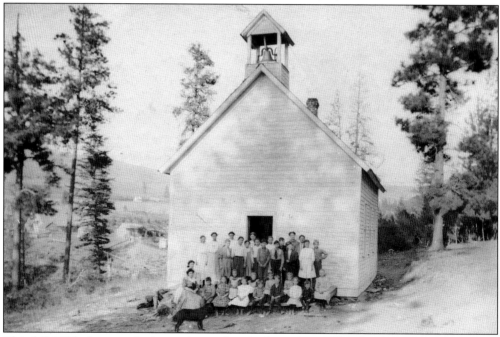

This fall 1907 photograph shows the student body in front of Cedonia School in Cedonia, Washington. This school was built in 1904 and was still standing in 2008. The teacher for Cedonia School District 35 was Anna Robinson. The district was established in 1891. This school was more commonly known as Harvey Creek School, as it was located on the banks of the stream. Members of the first school board were Martin Scotton, Loren Shaffen, J.G. Waters, and Nathan Young.

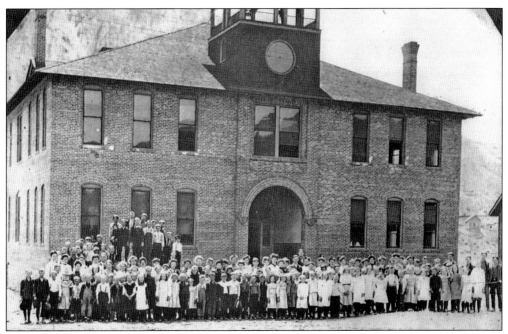

Northport School was located in District 53, which was organized by the superintendent, Jeff Slagle, on October 8, 1892. This district claimed territory that was transferred from the extensive Bruce Creek District 23. Its first school was located near Bishops Eddy, a short distance downstream from the town, and named for the Bishop family, who had property at the site.

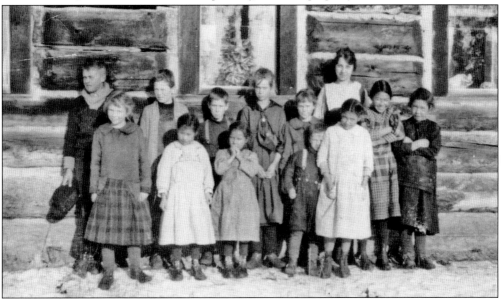

Stonespur School in District 100 (Sheep Creek) was created in November 1902 in a rural log house, which was built by the settlers in time for the summer term. Some Native American children are in the photograph. The students pictured include William Joyston, Jennie Wilson, Michael Phillips, Paul Wilson, Warren Williams, Julia Wedwards, May Moses, Dorothy Wilson, Ellen Moses, Alice Moses, and Ross Chester. Severe winters seemed the rule rather than the exception in the early days, so children with long distances to travel to school found it difficult to attend.

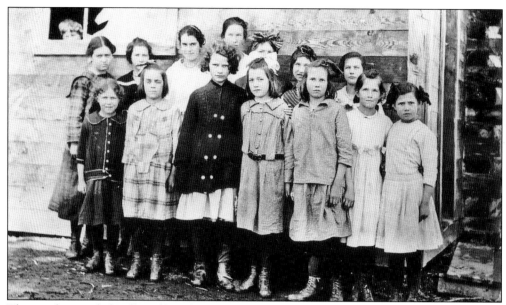

These girls attended Kelly Hill Girls School, located about 15 miles north of Kettle Falls. The lone exception to the girl students in this photograph is the boy peeking from the window. Shown here are, from left to right, (first row) Alma Jacobsen, Dorothy Rettinger, Francis Perkins, Elsie McNeal, Alice Craig, Cecile Cason, and Anna Perkins; (second row) Veols Hills, Artie McNeal, Alice Rettinger, Ethel Craig, Myrtle Cason, Clara Dahl, and Impsie Brant.

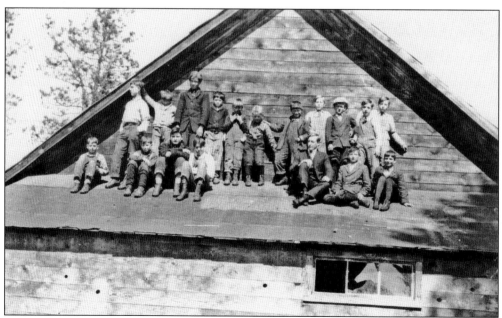

This Kelly Hill Boys School photograph shows the students with their teacher on the roof. This photograph was probably taken on the same day as the Kelly Hill Girls photograph, because the same window is broken in both images.

Hunters School was not far from the Columbia River in School District 54. The first class was held in the fall of 1892 in a small structure on the edge of town that had been built for a sorghum mill and the John Stevens Store. Bessie Troger McDowell described her memories of Hunters School: "That first year, I remember, there were less than a dozen pupils. Among them were Maud Hamilton, Sylvia and Golda Cameron, Albert and Grace Latta, and Bessie and Carl Troger. Our teacher was Ida King. In 1896 when the store burnt, Ralph Overmyer, a carpenter who was farming up Hunter Creek, was hired to construct a school building. School attendance grew rapidly."

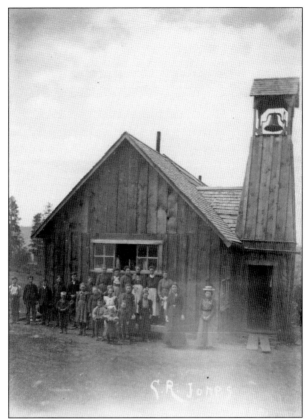

This was the original School No. 19 on the Lake Ellen Road on the west side of the Columbia River, in what is now Ferry County. Some of the students that would have attended this school were children of French Point, including the Lafleurs, Marchands, Mellens, and Toulous.

Students stand outside of the new No. 19 School, located on the Lake Ellen Road. The road was named after Ellen Marchand Stone. This school was also known as Stoney Acres.

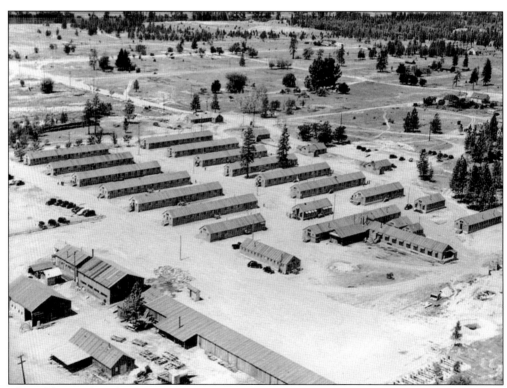
The Public Works Administration camp at Kettle Falls is pictured in 1939. Workers lived in this camp as they cleared river banks of trees and abandoned buildings to reduce navigational hazards in future Lake Roosevelt to be formed behind the Grand Coulee Dam.

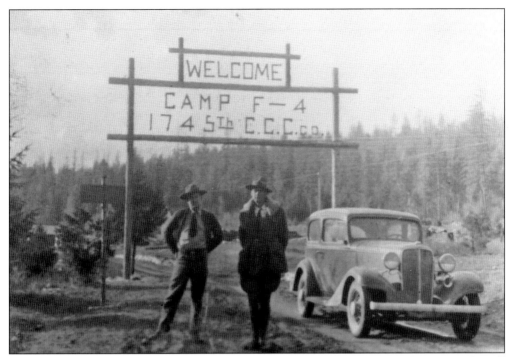

This entrance led to the Deadman Creek Civilian Conservation Corps Camp F-4. Ranger Russell Buckley is pictured on the right. This camp gathered at Deadman Creek and was located on the old Zombro Stevens homestead, which later became the site of White Pine Lumber. The camp was built to accommodate 220 men and was the base for operations.

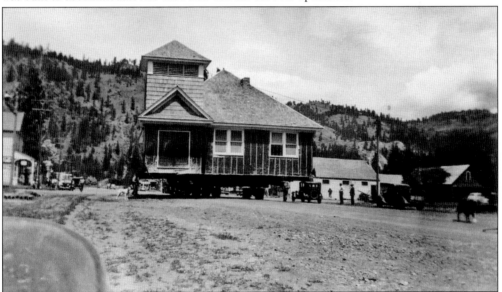

Kettle Falls Baptist Church was literally transported from "old" Kettle Falls to "new" Kettle Falls to avoid the impending backwaters following the construction of the Grand Coulee Dam and the formation of Lake Roosevelt. The church, now located at Fifth and Narcissus Streets, is still being used today. The Grand Coulee River backed up the Columbia to become Roosevelt Lake, flooding some communities. Kettle Falls moved, but some just disappeared.

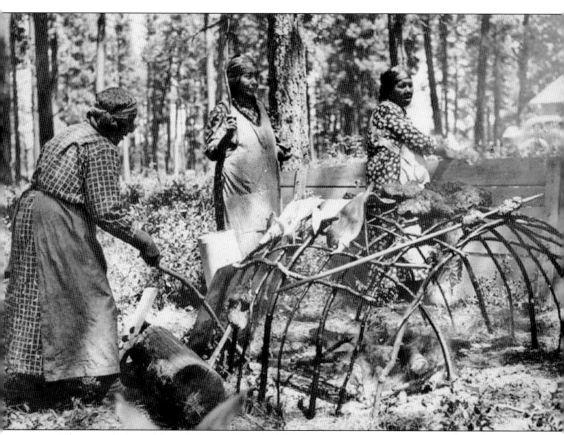

The completion of Grand Coulee Dam in 1939 brought economic prosperity from the increase in electrical energy and agricultural expansion through irrigation. It also brought an end to several thriving little towns and a way of life that had existed for at least 9,000 years. In 1939, a Ceremony of Tears was held not for the coming of the salmon but for their departure.

BIBLIOGRAPHY

Beckham, S.D. *This Place Is Romantic and Wild*. Eugene: Heritage Research Associates, 1984.
Burgunder, B. Recollections of Ben Burgunder. *Washington Historical Quarterly* 17 no. 3 (July 24, 1926).
De Smet, P.-J. *Life, Letters and Travels of Father Pierre-Jean de Smet, S.J., 1801–1873*. New York: Francis P. Harper, 1904.
Durham, N.W. (1912). *History of the City of Spokane and Spokane County, Washington: From Its Earliest Settlement to the Present Time*. Spokane: S.J. Clarke Publishing Company, 1912.
First Annual Report of the Railroad Commission of Washington to the Governor. Olympia: C.W. Gorham, 1907.
Foreign Office Correspondence. *Forty-Ninth Parallel West of the Summit of the Rocky Mountains*. Washington, DC: Government Printing Office, 1902.
Gibbs, G. *Indian Tribes of Washington Territory*. Fairfield, WA: Gallen Press, 1967.
Kane, P. *Wanderings of an Artist among the Indians of North America*. London: Longman, Brown, Green, Longmane, and Roberts, 1859.
Merk, F. *Fur Trade and Empire: George Simpson's Journal*. Cambridge: Harvard University, 1931.
Naff, A. *The Last Bell*. Colville: Don's Printery, 1984.
Phillips, W.S. *The Journal of John Work*. Cleveland: Arthur H. Clark Company, 1923.
Pierce, F.L. *Report of an Expedition from Fort Colville to Puget Sound, Washington Territory*. Washington, DC: Government Printing Office, 1883.
Session Laws of the Territory of Washington. Olympia: James Lodge, Public Printer, 1861.
Steele, R.F. *An Illustrated History of Stevens, Ferry, Okanogan, and Chelan Counties State of Washington*. Spokane: Western Historical Publishing Company, 1904.
Stevens, H. *The Life of Isaac Ingalls Stevens*. vol 1. Boston: Houghton, Mifflin and Co., 1900.
Tenth Annual Report of the Public Service Commission of Washington to the Governor. Olympia: Frank M. Lamborn, 1920.
Tyrrell, J.B., ed. *David Thompson's Narrative of His Explorations in Western America, 1784–1812*. Toronto: The Champlain Society, 1916.
US War Department. *Reports of Explorations and Surveys, to Ascertain the Most Practicable and Economical Route for a Railroad from the Mississippi River to the Pacific Ocean: 1853–1855*. Washington, DC: Thomas H. Ford, 1860.
Works Projects Administration. *Told by the Pioneers . . . Tales of Frontier Life as Told by Those Who Remember the Days of the Territory and Early Statehood of Washington*. Olympia: 1937, 1938.

Discover Thousands of Local History Books
Featuring Millions of Vintage Images

Arcadia Publishing, the leading local history publisher in the United States, is committed to making history accessible and meaningful through publishing books that celebrate and preserve the heritage of America's people and places.

Find more books like this at
www.arcadiapublishing.com

Search for your hometown history, your old stomping grounds, and even your favorite sports team.

Consistent with our mission to preserve history on a local level, this book was printed in South Carolina on American-made paper and manufactured entirely in the United States. Products carrying the accredited Forest Stewardship Council (FSC) label are printed on 100 percent FSC-certified paper.